IMAGES
of America

DUNEDIN

IMAGES
of America

DUNEDIN

Vincent Luisi and A.M. de Quesada Jr.

ARCADIA
PUBLISHING

Copyright © 1999 by Vincent Luisi and A.M. de Quesada Jr.
ISBN 978-0-7385-0059-1

Published by Arcadia Publishing
Charleston SC, Chicago IL, Portsmouth NH, San Francisco CA

Printed in the United States of America

Library of Congress Catalog Card Number: 99-60795

For all general information contact Arcadia Publishing at:
Telephone 843-853-2070
Fax 843-853-0044
E-mail sales@arcadiapublishing.com
For customer service and orders:
Toll-Free 1-888-313-2665

Visit us on the Internet at www.arcadiapublishing.com

*To my understanding wife Lucy and beautiful daughter Erin,
who are my inspiration for all my projects.*

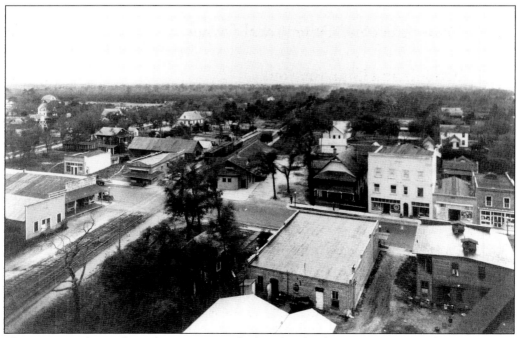

This is an aerial view from the water tower looking south of Main Street, Dunedin, c. 1919.

CONTENTS

ACKNOWLEDGMENTS

The authors would like to thank the people of Dunedin for the donations of their precious photographic archives to the Historical Museum Collection and Mayor Tom Anderson and the city commissioners for their support.

The Dunedin Museum Historical Archives, *Dunedin* by M. W. Moore, *The History of Dunedin* by Lovett Douglas, *The First Hundred Years of Dunedin* by the Dunedin Historical Society, *Dunedin . . . Thru the Years* by Al Cline and William Davidson, and the *Visitor's Guidebook to "Delightful" Dunedin* were all valuable sources of information.

The authors would also like to thank Evelyn Wheeler Towler, Vivian Skinner Grant, Jack Zweck, and all the Dunedin Historical Society volunteers who assisted in research and preparation for this book.

Vincent Luisi
A. M. de Quesada Jr.

INTRODUCTION

As one walks through the beautiful renovated downtown area of Dunedin with its different restaurants and various shops, many would find it hard to believe that this community grew from a general store, a dock, and particularly from two men of Scottish heritage.

The origins of the community can be traced to 1870, when John Branch built the settlement's first store on the waterfront, where supplies would come in by trading schooners from the Mobile region. A dock was built next to the store, but business was not profitable as settlers were few, forcing Mr. Branch to eventually leave. The dock continued to be used by passing schooners for fresh water and trade goods. Dunedin has always been known to have the best drinking water on the west coast because of its artesian wells. If one walks through Edgewater Park today, the old water fountains where people would get their fresh water supply can still be seen.

The settlement was raising crops such as watermelons, sweet potatoes, and oranges. Since many of the early settlers were from the Southern states, cotton was also raised, although the development of the citrus industry was another 20 years away. Cotton eventually became the main crop in the settlement in the early 1870s, so it was only natural that someone would build a cotton gin. Major M.G. Anderson put up a small cotton gin, operated by horse power, to prepare the cotton for marketing. Schooners using the dock would pick up the cotton and travel to New Orleans for selling and trading.

Log houses were scattered around the settlement and in the pine forest. Footpaths and rutted wagon roads linked neighbor with neighbor, and all the trails eventually found their way to the waterfront and the dock. It was around this same time that George L. Jones and his family opened a general store and trading post. It was he who gave the settlement its first name, calling it Jonesboro. Settlers started to recognize the village as Jonesboro because of Mr. Jones's sign on his general store, but that name was short-lived.

A few months later, two Scotsmen arrived in the village of Jonesboro. J.O. Douglas and James Somerville opened a general store in the cotton gin building. They were not happy with the name Jonesboro and started to promote a new name for the settlement. The name they wanted to use was Dunedin, the Gaelic interpretation of Edinburgh, their hometown in Scotland. Dunedin has many interpretations but the most common usage of the word means "Dun" (rock) and "Eiden" (Castle), or "The Castle on the Rock."

The conflict between Jones and Douglas/Somerville became a heated topic but was soon put to an end. As the Douglas/Somerville store became popular, the two men moved the store into a two-story building at the water's edge, and built a long pier out into the bay. The Douglas/

Somerville store served a large area, including the communities of Clearwater and Largo. With this surge of popularity, the two Scotsmen decided to get official permission to name the settlement. Douglas and Somerville petitioned the government for a post office to be located in their large general store, allowing them to "officially" name the settlement Dunedin. The Jones family continued to run their general store for a while but eventually closed the store and went into another business. Ironically, after the official naming of the settlement, Jones and Douglas/Somerville made amends and became friends and continued to help the community.

Dunedin used to be served by coastal schooners, but the advent of steam was a great day for local residents. Forewarned of the arrival of the Eva, a Mississippi River sternwheeler in 1880, the whole town turned out in welcome. The captain invited the folks aboard in a gesture of goodwill, whereupon they promptly ate and drank everything aboard. While the Eva ran down to Dunedin for several years, the deep water was also navigable for other big ships. The *Sophie Bierman*, an 80-ton schooner, was one of these that kept a regular monthly schedule. The *Sophie* could come fairly close to shore, but not close enough to tie up at the dock. Residents used to drive a wagon out into the bay until the floor was just above the water, and the crew would ferry supplies from the schooner to the wagon in a dory.

Development continued in the community, and in 1888, Dunedin took another step forward when the Orange Belt Railway came through town. The first depot was an empty boxcar, but eventually became a main stop with a real railroad station for passengers and freight shipment. Dunedin gradually grew and its people prospered. The settlement formed around the places of business, and the community center started to thrive, and by 1898, Dunedin had approximately 100 inhabitants.

Pork was a staple diet for many in the area. However, a problem arose when settlers' hogs roamed freely throughout the town and destroyed property. Many felt that a law could be initiated if the settlement was incorporated, so in 1899, Dunedin was granted its town charter. Ironically, the hog law didn't work well, as people still fought about the hogs. L.B. Skinner, one of the first councilmen of Dunedin, was asked by the marshal what to do. Marshal was quoted as saying, "Ignore it, no use a lot of people getting killed over a bunch of hogs!"

Dunedin has grown tremendously since its incorporation a century ago. There have been highs and lows, but most people still think the town is a great place to live. And when Dunedin residents celebrate their 100 years of incorporation, they can think back about the general store, the dock, Jonesboro, those Scotsmen, sailing vessels, and those damn hogs.

One

A SETTLEMENT GROWS

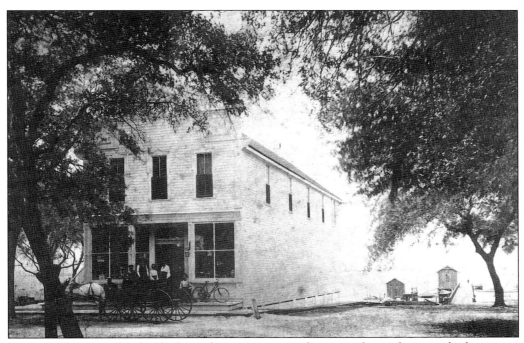

By the 1870s, several individuals tried to open a general store in the settlement which at times was called Jonesboro, but none were profitable. By 1872, two Scots opened the Douglas and Somerville General Store, which served a large segment of the population, including the communities of Clearwater and Largo. Douglas and Somerville were also granted a petition to open the community's first post office, allowing them to officially name the town Dunedin, which is Gaelic for Edinburgh, their Scottish home.

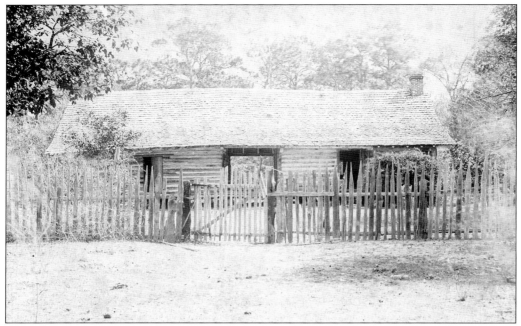

One of the earliest pioneer homes in Dunedin, a southern-style log house shown here *c.* 1880, was built by the Marston family. It was located on the northwest corner of Highland Avenue and Scotland Street across from the property owned by the Presbyterian church. Note the breezeway with cooking area on one side and living quarters on the other.

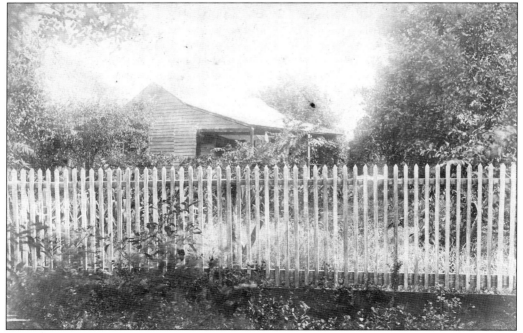

This is a side view of the Marston family log cabin, *c.* 1880. The log cabin would be replaced by a more modern home in the early 1900s.

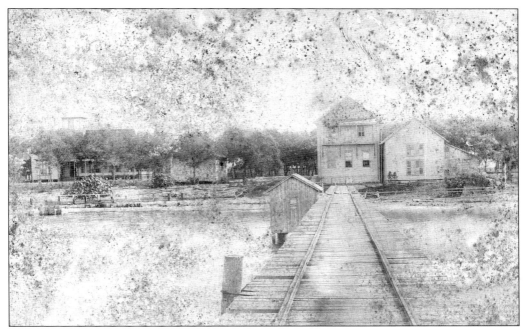

Looking east from the end of the loading dock, c. 1880, the Douglas and Somerville store and cotton gin can be seen. To the left can be seen the home built by George L. Jones.

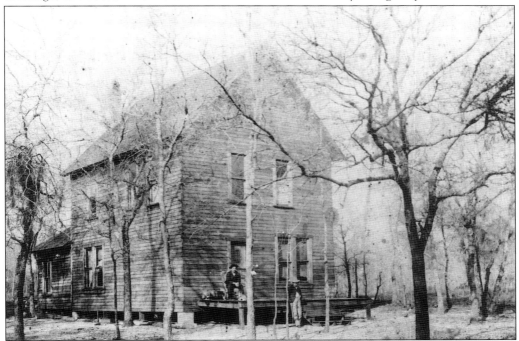

One of the oldest pioneer families for which there are photographic records is the Andrews family. Allen Andrews came to the Dunedin area in 1876 at age 22 and homesteaded a tract of land on what is now Union Street. In 1905, Andrews built the home shown here on Virginia Street, between Douglas and Highland, so his youngsters would be close to school.

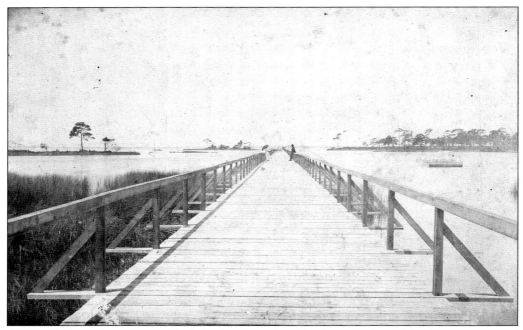

A long dock to deep water afforded a landing place for ships in the 1880s. Here, cargo and supplies were unloaded for settlers from Safety Harbor to Clearwater to Sutherland (Palm Harbor). Cotton, a crop produced in early Dunedin, could also be easily loaded aboard ships for export from the cotton gin located at the foot of the dock.

Built in 1878 by settler J.O. Douglas and shown here c. 1920, this is the oldest existing home in Dunedin and is listed in the National Register of Historic Places. It was the first home to be built with "shop cut" lumber planks, which were shipped from Cedar Key. The house is now a delightful bed and breakfast located at 209 Scotland Street.

Shown here is a c. 1880s view towards the outskirts of the settlement of Dunedin, near the Andrews property. A settler in a horse-drawn buggy examines the cut lumber that will be used by local residents.

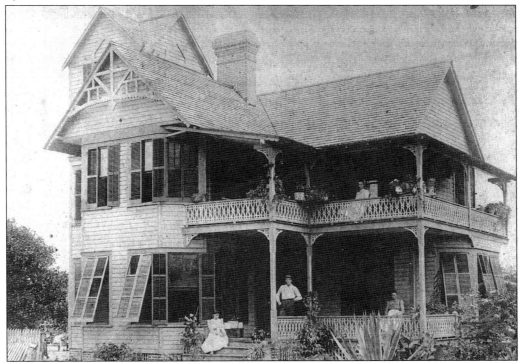

The George L. Jones home was built in the early 1880s and was an impressive site in early Dunedin. When the Joneses sold their house it became the Blue Moon Inn. In 1926, Dr. John Andrew Mease made the inn into a ten-bed sanatorium. The building no longer exists but stood where the Sun Blest Apartments are today.

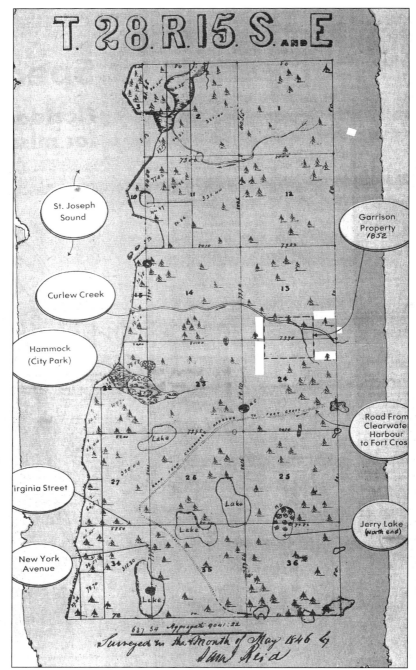

A U.S. Geological survey map of Florida dated May 1846 shows the area that would become Dunedin. The map shows highlighted areas that were established when Dunedin started to grow. The first land grant to be awarded in the Dunedin area was to a homesteader by the name of Richard L. Garrison, who recorded his deed for 160 acres near Curlew Creek in 1852. He received the land under the Bounty Land Act of 1850, for his services in the Seminole Indian Wars. While returning home from a Civil War Union prison camp, he died from an illness.

14

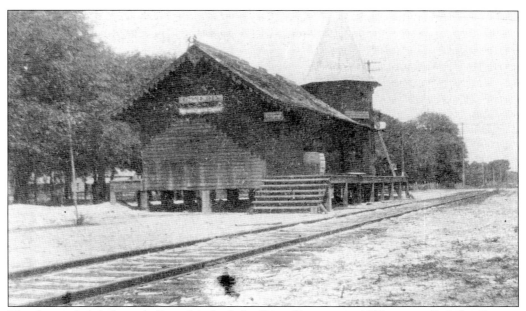

The first railroad through Dunedin, built by Peter Demens in 1888, was called the Orange Belt Railroad. It was a narrow gauge track running from Sanford through Tarpon Springs and Dunedin, and ending in St. Petersburg. The first depot, a boxcar, was replaced in 1890 with this wooden structure, shown here as it appeared c. 1890. It had a water tank for servicing the steam locomotives.

Dunedin's Main Street was first called Oak Street due to all the large oak trees that lined the street. There was a footpath to the right for pedestrians, and horses and buggies used the wider stretch in the middle. This photo was taken in the early 1890s.

Here, a settler in a horse and buggy is riding along Oak Street. The view was taken *c.* 1890 looking west on Oak Street.

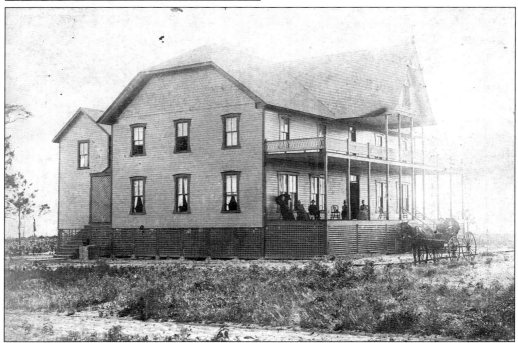

A two-story rooming house that was built on the southwest corner of Albert Street and Edgewater Drive is shown here as it appeared about 1890.

Andrews Memorial Church was originally located in the area of the present site of the Dunedin Cemetery on Keene Road. In 1888, this new church, shown as it appeared *c.* 1890, was built on the southwest corner of Highland Avenue and Scotland Street. The original church was dismantled and used for parts in other buildings, including the local Dunedin schoolhouse. Members of the Presbyterian church had decided that their church needed to be closer to the Main Street location.

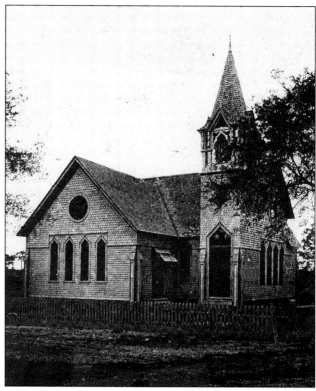

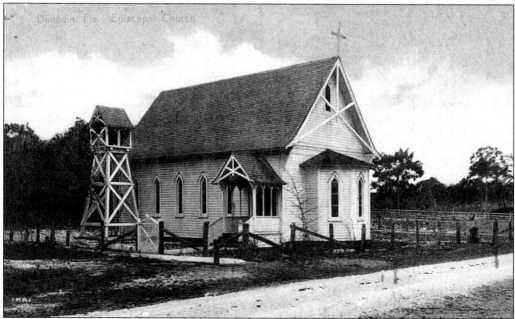

Church of the Good Shepherd (Episcopal), located on the southeast corner of Edgewater Drive and Albert Street, was completed in March 1889. The first two marriages consecrated there were those of the vicar himself and of the Duke and Duchess of Sutherland.

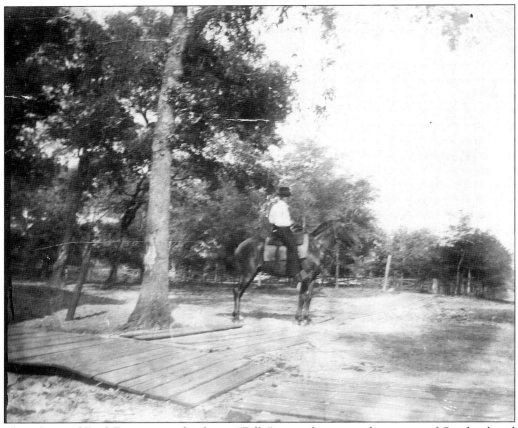

This photo of Fred Emerson on his horse "Billy" was taken near the corner of Scotland and Edgewater by local resident Eva Bouton, *c.* 1898.

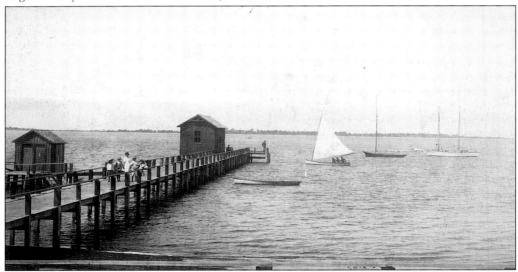

This is a *c.* 1890s "tourism" card of the Dunedin dock entitled "A Glimpse of the Bay, Dunedin, Fla."

Main Street in the 1890s was shaded by huge oaks and lined by fences designed to keep roaming hogs out of settlers' yards.

The Dunedin Yacht Club and Skating Rink building was erected in the late 1880s near the center of present-day Edgewater Park by two yachtsmen, C.B. Bouton and L.H. Malone. On the first floor was a meeting room for the Yacht Club crowd, as well as two apartments. The second floor was used for roller skating, plays, dances, and many civic and social events. In 1895, C.B. Bouton gave 200 books to start a library on the ground floor, and the building became known as Library Hall. In 1899, Dunedin incorporated, and town council meetings were held there until 1912. The building served as a community center until it was dismantled in the 1950s. The Dunedin Library is the oldest continuously operated library in Pinellas County.

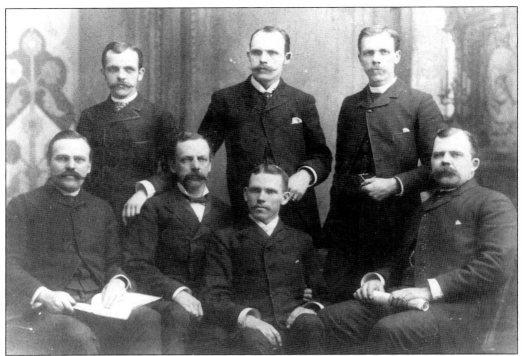

The seven Malone brothers from Cleveland, Ohio, began vacationing in Dunedin in the 1880s. Eventually, several of them would build beautiful and expensive homes on Victoria Drive. The Malones and other prominent residents chartered the Dunedin Yacht Club. Levi H. Malone (bottom left) became the club's first commodore and donated the Malone Silver Competitive Racing Trophy to list all the future winners of the yearly Yacht Club Races.

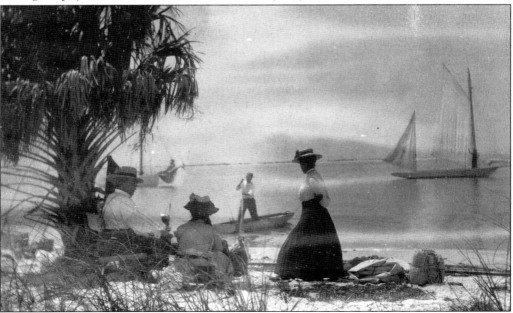

After having sailed over to Hog Island from Dunedin, this family found a shady spot to rest.

Victoria Drive, named after Queen Victoria, became the area of expensive homes of prominent residents of Dunedin such as the Skinner, Bouton, and Malone families. Many families would arrive during the winter and stay for half a year, while others were permanent residents. This postcard view shows Victoria Drive looking south towards the City Dock, c. 1900.

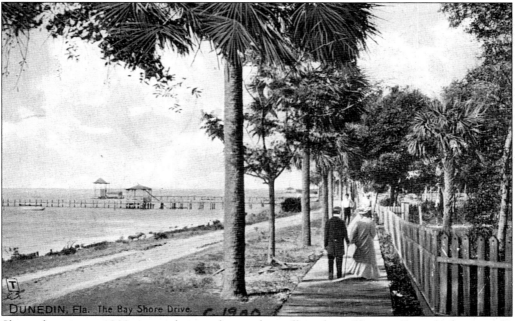

Shown here is a c. 1900 postcard view of a couple strolling down Victoria Drive looking north. Notice that most of the homes had their own personal docks for their sailing vessels.

21

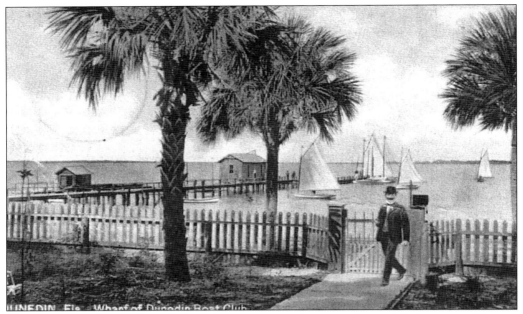

This is a postcard view of a well-dressed man entering the gates of one of the homes on Victoria Drive near the corner of Victoria and Monroe Streets. The Dunedin Yacht Club Inn dock is pictured behind him.

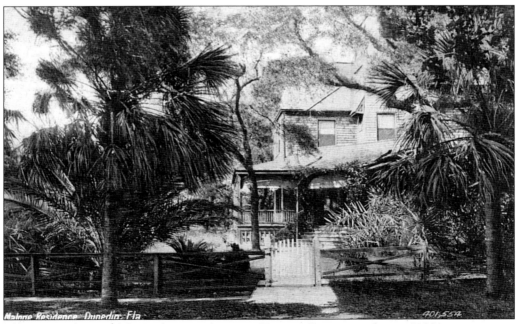

This postcard view of the Malone residence on Victoria Drive was taken c. 1900.

This photographic view of L.B. Skinner's home on the corner of Victoria Drive and Jackson Street was taken looking from southwest to northeast. This is the present site of Victoria Apartments.

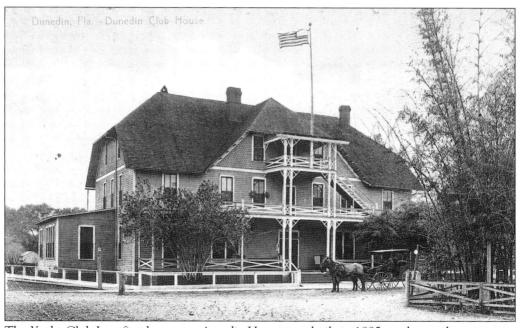

The Yacht Club Inn, first known as Arcadia House, was built in 1885 on the southwest corner of Broadway and Monroe Streets. It was built as a hotel with lavish accommodations and was patronized by the wealthy guests of the yachting set. Many of the residents of Victoria Drive would frequent the Inn or the Inn's dining room. The Inn remained standing until 1984, when it was destroyed by fire.

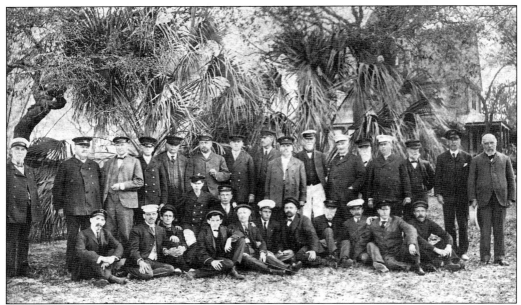

Many Dunedin residents were avid sailors and held organized sailing events. On January 6, 1903, a meeting was held by all of the interested residents of Dunedin for the purpose of organizing a Yacht Club. On February 9, 1903, a formal constitution was adopted and 16 individuals became charter members of the Dunedin Yacht Club of Florida. As part of the charter it was accepted that the organization would not just be a social group but would conduct competitive races. Mr. L.H. Malone donated a silver cup, calling it the Competitive Cup, and names of the winners of the yearly races were to be inscribed on the cup. This is a photograph of the Yacht Club members between 1903 and 1904.

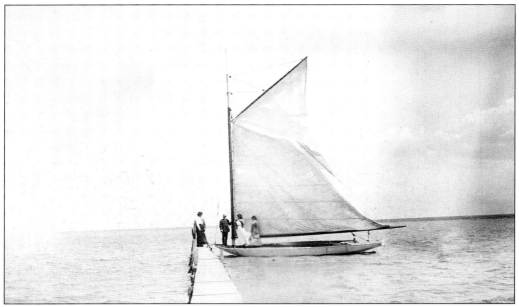

Many of the members of the Yacht Club had their own vessels. This "catboat," called the *Wisconsin*, was owned by L.B. Skinner.

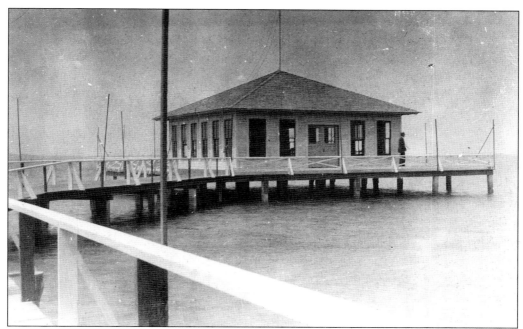

The Yacht Club Inn had its own dock on the waterfront at the corner of Monroe Street and Victoria Drive. Only members or guests at the Inn had the use of this facility. Local residents of Dunedin had to use the City Dock located south of the pavilion.

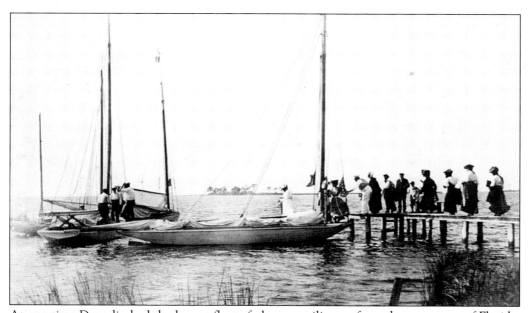

At one time Dunedin had the largest fleet of pleasure sailing craft on the west coast of Florida. In this *c.* 1900 photograph, the women on the dock are waiting to get into the sailboats to picnic on either Clearwater or Hog Island.

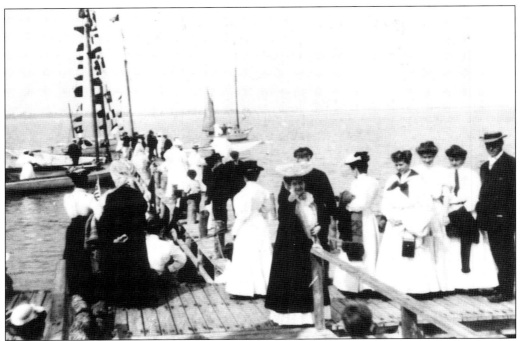

Ladies and gentlemen gathered together for a day of sailing and racing. Even though it was a day of fun and enjoyment, proper dress was still a requirement. Note the racing flags on several of the sailboats.

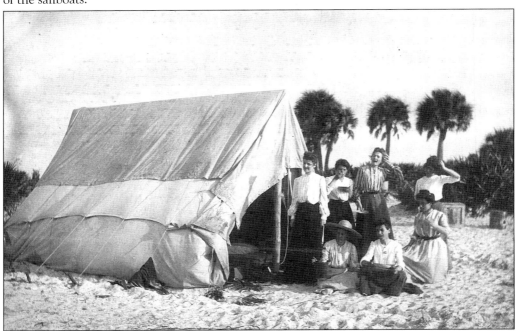

In this photograph some of the young ladies have sailed over to Hog (Caladesi) Island and set up a campsite for the day. They have brought a lunch and will enjoy a day of swimming, hiking, and nature. The caption on the photo called this campsite "Adamless Eden."

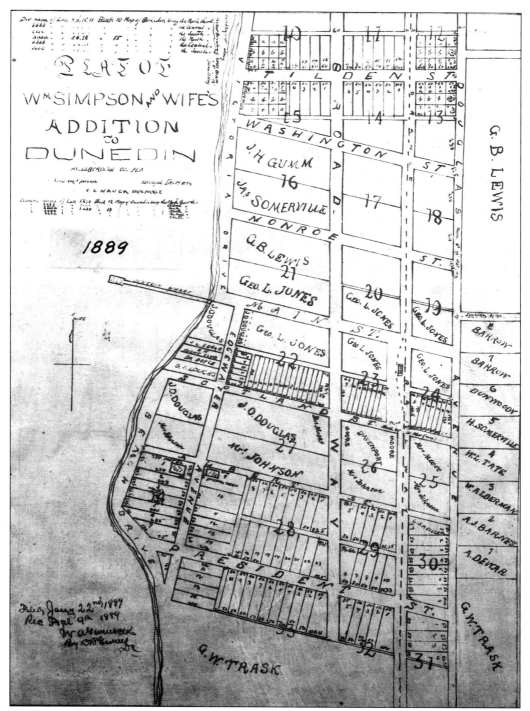

A photograph of an 1889 street map of Dunedin outlines all the existing properties and property owners. Many of the original settlers owned a great deal of property along the waterfront in the 1880s.

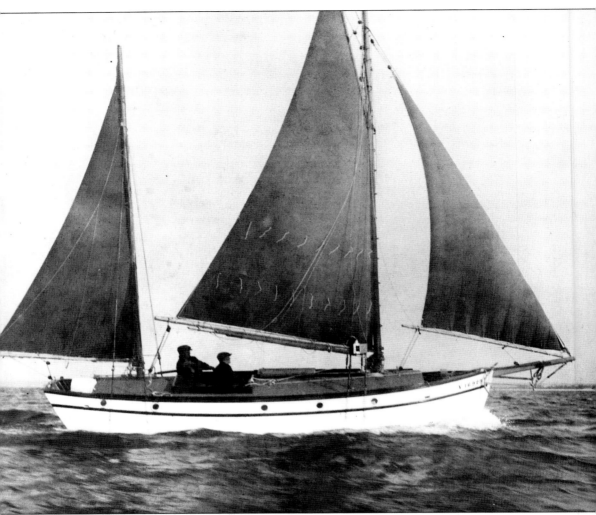

This is a typical racing yacht from the Dunedin Yacht Club fleet. This yacht, called the *Wyomi*, was built by local resident John G. Hanna, who resided at 959 Victoria Drive. Mr. Hanna was a well-known ship designer.

Two

Main Street and Other Local Scenes

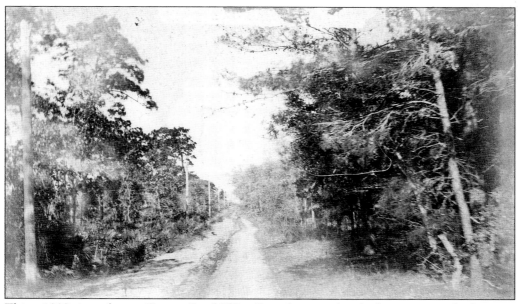

This *c.* 1900 view of upper County Road 580 in Dunedin was taken looking east past the location of present-day County Road One. Individuals traveling to Tampa would use this road.

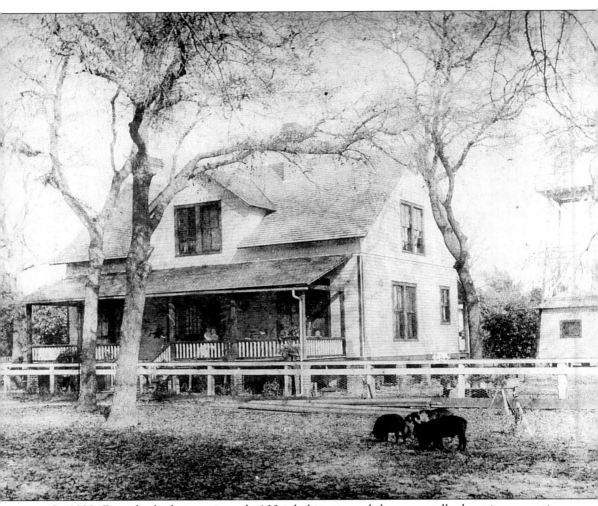

In 1898, Dunedin had approximately 100 inhabitants, and there was talk about incorporating the town. The residents might have delayed incorporating the town if it had not been for a "hog" problem. It seems that most families kept hogs because beef was rare and refrigeration was not available. The hogs would be slaughtered and salted to be used later, but the problem was that while alive the hogs roamed throughout the town and caused destruction and litter problems. Many believed that a law could be initiated if the town incorporated. In 1899, a charter for the town of Dunedin was applied for and granted. Ironically, the hog law did not work well, and residents still fought about the hogs for several years. (Courtesy Heritage Village Museum.)

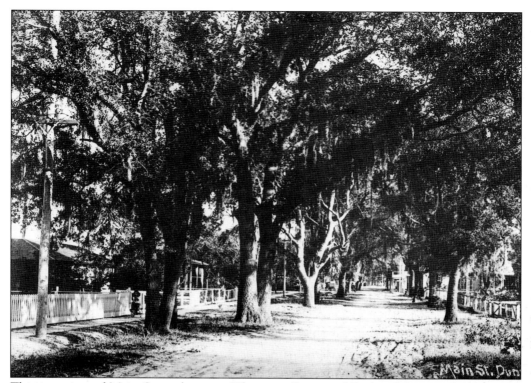

This is a view of Main Street between Edgewater Drive and Railroad Avenue looking east. Note the condition of the road from rain and heavy use. Within a few years after this photo was taken, Main Street would have a completely different appearance.

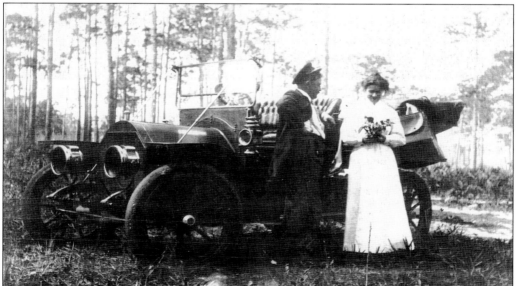

In 1906, L.B. Skinner purchased the first automobile to arrive in Dunedin, a chain-driven REO. Skinner used it primarily to take his family to Tampa to visit the Hillsboro Hotel, which he owned. Standing next to L.B. Skinner is his daughter Elizabeth.

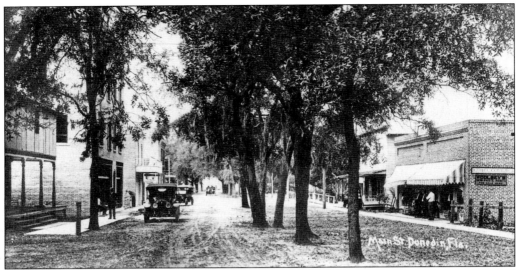

In the early 1900s, Main Street from Douglas Avenue to Edgewater Drive was a dirt road shaded by large oaks. The town of Dunedin had been incorporated in 1899. In 1915, Pinellas County paved its first road—County Road One. Dunedin's town fathers decided that Main Street had to be paved and the oaks had to come down. A strong protest against cutting the trees was voted down. When a crew of men started to cut the trees, several ladies of the community protested by sitting on the saws. The town marshal dismissed the workmen, and the ladies went home. When they returned the next day to continue their protest, they found the oaks had been cut down early that morning.

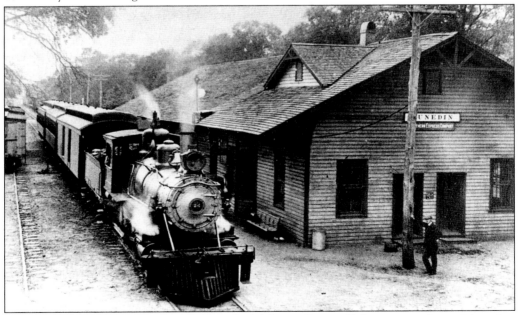

When the Plant Railroad Line took over the bankrupt Orange Belt, a more substantial station was constructed to replace the original. Not only was the station replaced, but the narrow gauge tracks were removed and replaced with standard gauge, so all steam locomotives could use the tracks. This view, taken looking south, shows the depot as it appeared in 1912.

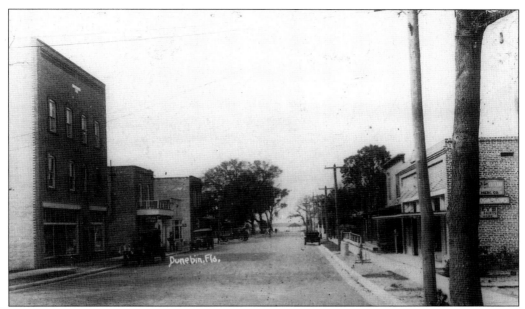

In 1911, the eastern portion of Hillsborough County separated and became Pinellas County. One of the first programs the new county initiated was to build a public road, which was completed in 1915. From Main Street, Dunedin, one could now travel in comfort to Clearwater or to Sutherland (Palm Harbor).

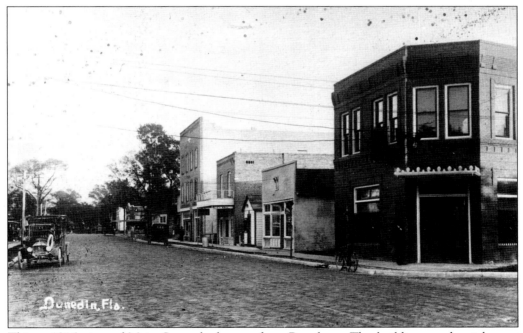

This c. 1916 view of Main Street looks east from Broadway. The building on the right was the new Bank of Dunedin, which officially opened in October 1913. The first president and director of the bank was Alfred J. Grant.

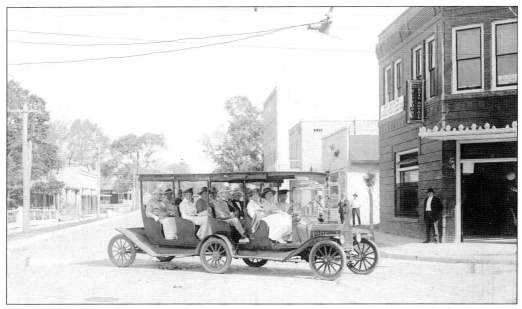

This photo, dated 1917, shows the corner of Main Street and Broadway with the six-wheel "Jitney Car" parked next to the Bank of Dunedin. The Jitney, made from two Ford cars, traveled from Dunedin to Clearwater on the new County Road and could carry 12 passengers. It also took two drivers, with one seated in the back, to help steer around corners.

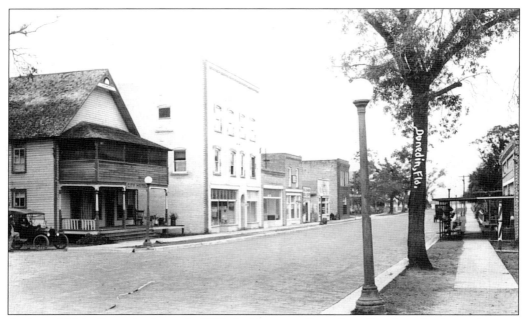

A view of Main Street in the early 1920s looking west from the railroad tracks shows the two-story house on the far left, which housed the Western Union office on the first floor. The three-story structure next to the telegraph office was owned by Jesse Boyd.

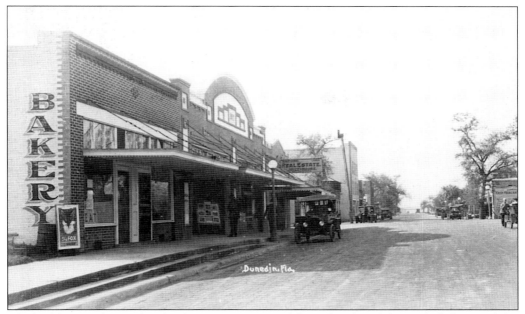

The building on the south side of Main Street east of the railroad track housed a bakery and the Dixie Theater.

In this view of President Street looking west down the row of homes, notice that the large trees that line the street today were just starting to grow in the 1920s.

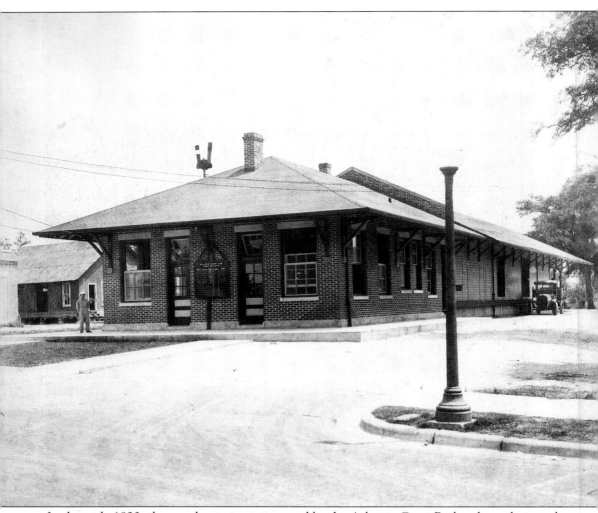

In the early 1920s the wooden train station used by the Atlantic Coast Railroad was destroyed by a fire. A new station made of bricks was completed in 1922. This c. 1923 view was taken looking south at the station with the new freight house in the back section. The Feed Store is to the left across the tracks from the train station.

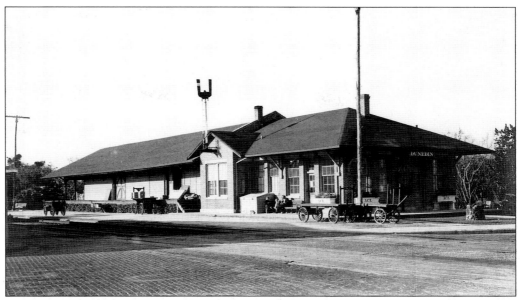

A *c.* 1920s view of the brick railroad station looking at the east side shows the baggage carts used for baggage and freight deliveries.

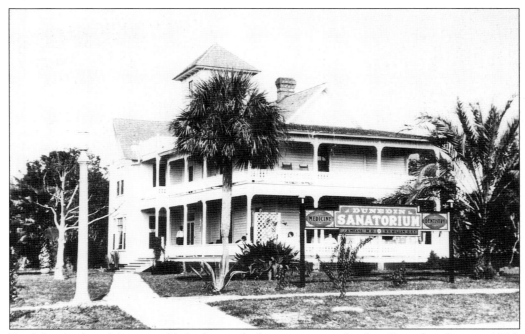

Dr. John Andrew Mease established a ten-bed sanatorium as his first Dunedin clinic in 1926. The building , shown here *c.* 1930, was originally called the George Jones home, and then later the Blue Moon Inn.

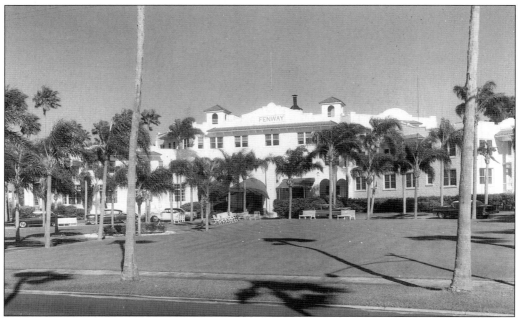

The luxurious Fenway Hotel, built in 1925–1926, was the home of Pinellas County's first radio station, WGHB. The hotel complex was sold to Trinity College in 1961 and became an academy and Bible center. In 1987, Trinity College moved to Pasco, and the facility remained closed until 1991. At that time the building was renovated and opened as Schiller International University for students from more than 100 countries who were interested in international business and tourism. This photo was taken in the 1950s.

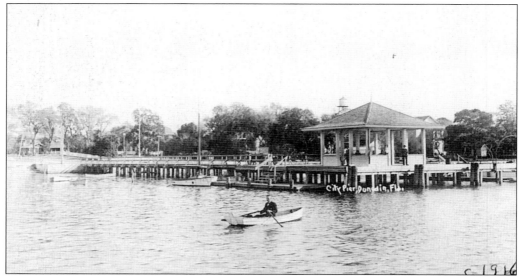

The Dunedin Dock was always an integral part of Dunedin's history. Supplies arrived at this dock before the railroad was built. The dock was also the main stop of travel for shippers who would run supplies from Cedar Key to Key West. By 1916, it had become more of a fishing and sailing center for the community. In this 1916 photograph, a resident rows past the newly extended dock with its new pavilion.

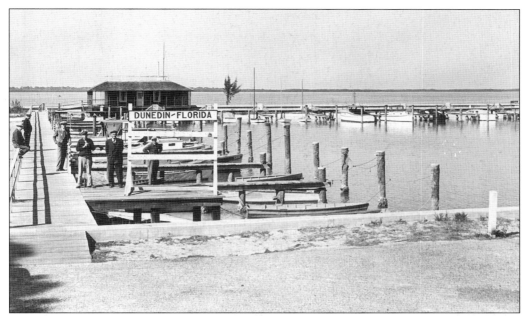

The Dunedin Boat Club is in the background of this early view of the extended Dunedin marina and boat dock. Fisherman and local residents pose by the Dunedin/Florida fishing rack. This early 1930s photo was used by the Chamber of Commerce for publicity purposes.

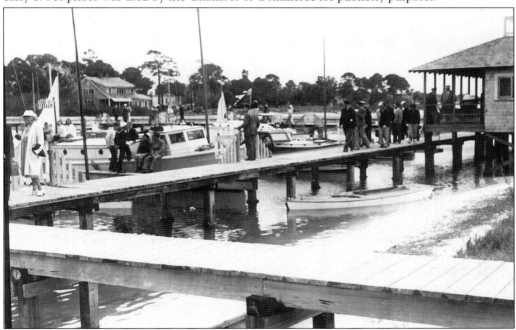

The Dunedin Boat Club was founded in 1929 by 31 charter members who were disenchanted with the "old folks" in the Yacht Club crowd. Their goal was to develop and maintain the "Boat Basin" or marina. Eventually, the active members of the Dunedin Yacht Club merged with the Boat Club and became one club. In this 1930s photo, members of the Boat Club leave the building after their regular meeting.

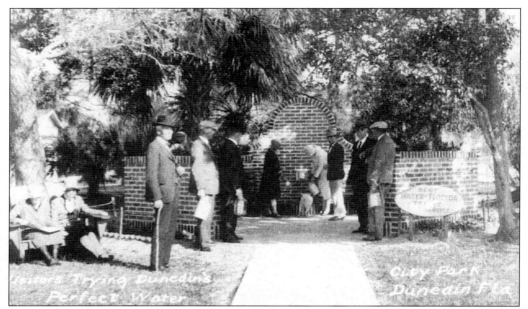

Dunedin had several artesian wells that produced what was considered the best water on the west coast. People from all over the Tampa Bay area came for the delicious, fresh Dunedin water. Here people fill their water jugs from the water fountain in Edgewater (City) park *c.* 1920s.

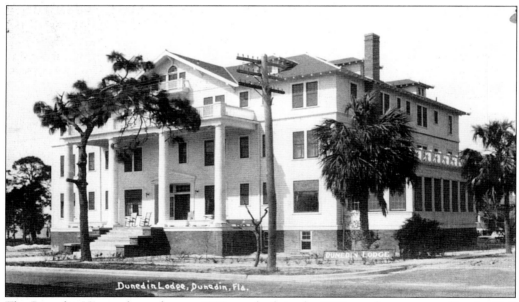

The Dunedin House, shown here *c.* 1930, was built in the 1880s, and was managed by the Bull sisters, Matilda and Lydia, on a seasonal basis. The house went through a period of renovation, with the main entrance facing Edgewater Drive. The name was also changed to the Dunedin Lodge or Dunedin Hotel. In the 1940s the hotel became the headquarters for the U.S. Marines based in the Dunedin area. After the war the hotel became a private residence. The building was torn down in the 1970s and replaced with the Edgewater Arms.

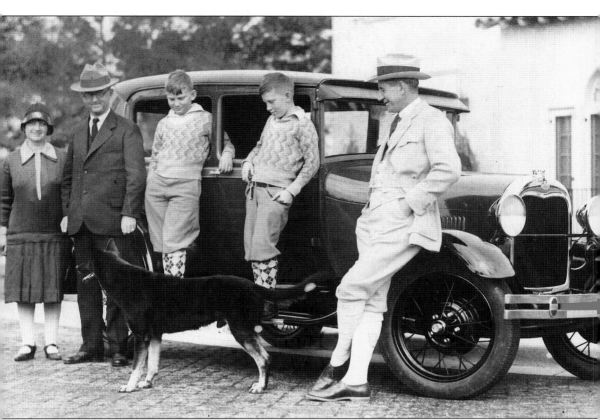

E.S. Frischkorn, developer of Dunedin Isles (right side), with Judge Dingeman and family, admires a new Model A Ford that had been delivered to the Frischkorn home. This *c.* 1927 photo was used in a public relations promotion for Dunedin Isles by the Chamber of Commerce.

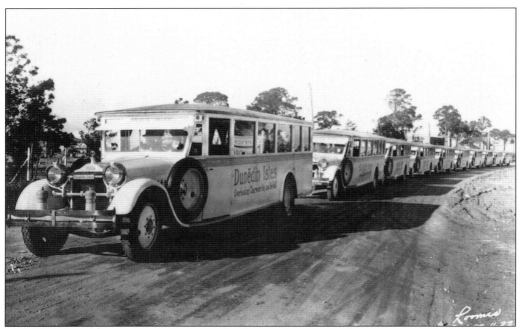

Here is part of a fleet of 23 white "parlor car" buses bringing prospective buyers to Dunedin to purchase lots in Dunedin Isles in 1926. Dunedin Isles had 6,200 lots for sale covering 3,000 acres.

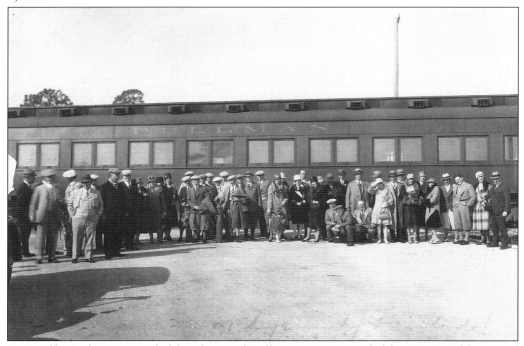

More affluent buyers traveled by chartered Pullman trains provided by E.S. Frischkorn and arrived at the Dunedin train station. Here a group of prospective purchasers arrive from Michigan in 1927.

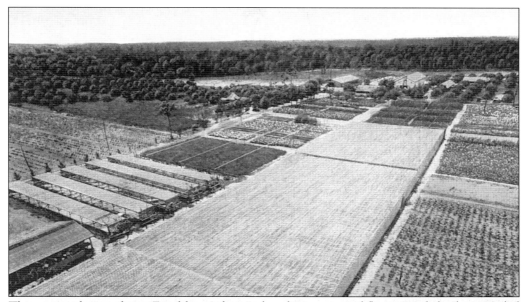

This postcard view shows Frischkorn's horticultural inventory of flowers and shrubs intended for Dunedin Isles. These plants were used for parks, boulevards, waterfront areas, and homes. At one time his nursery boasted over one million specimens. By 1930 the area was blanketed instead with weeds and crabgrass after the stock market crash and the land boom had ended in Florida.

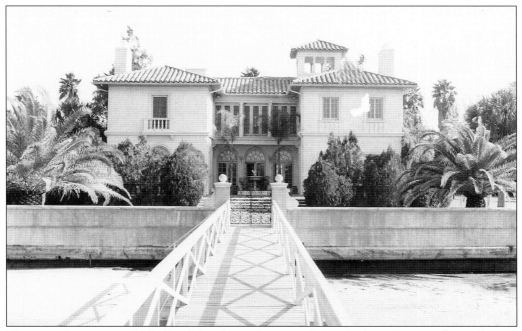

The waterfront view of Mr. Frischkorn's residence on Santa Barbara Drive is shown here c. 1927. Although he built this home for himself, he eventually sold it to cereal king W.K. Kellogg of Battle Creek, Michigan, who used it as his winter residence. The home still exists today as a private residence.

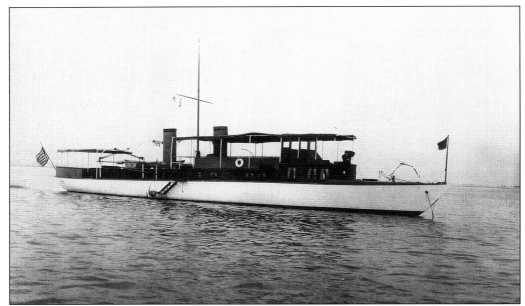

This yacht named *Javelin*, shown here *c.* 1927, valued at $75,000, was owned by Col. Fred Warner, who lived in Dunedin Isles. On September 3, 1927, while crew members readied the yacht for a cruise, the engine caught fire, the ship exploded, burned to the water level, and sank. Nine years later, four Dunedin youths built their own diving suit (including a diving helmet made from a hot water tank) and salvaged the ship's propellers and bronze fixtures. (Courtesy of Mayor Tom Anderson.)

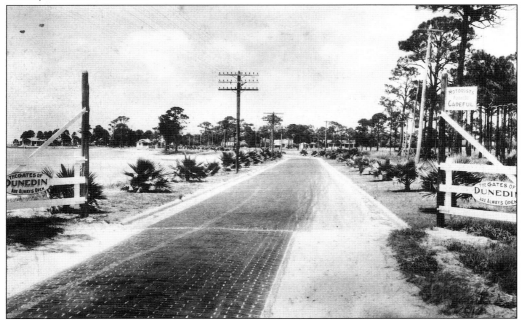

In this early 1920s view of the Edgewater Drive entrance gate to the city limits of Dunedin, notice that the county road entering Clearwater does not extend the full 14-foot width. Dunedin had paid to extend its portion of the county road the full width.

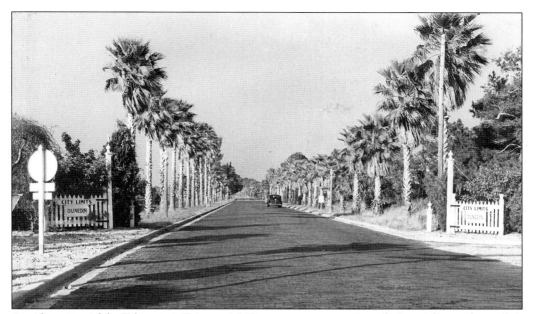

Another view of the Edgewater Drive, *c.* 1940, entrance gate to Dunedin's city limits shows that the county had eventually widened the road. The City of Dunedin then removed the telephone poles and added lamp posts and tall palm trees along the route of Edgewater Drive.

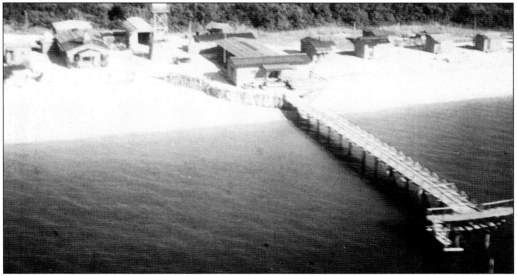

In 1938, Clinton M. Washburn purchased the northern part of Caladesi, or Hog Island, for $25,000 from a group of Tampa businessmen. He came up with the idea to use the island as a honeymoon getaway for newly married couples. *Life* magazine covered the story in 1940. Fifty rustic cottages were built on Honeymoon Island along with several all-purpose recreational and dining buildings. To get to Honeymoon Island, couples took a charter boat. When the United States entered World War II, the island was used by a defense manufacturer for rest and recreation for his employees. In 1956, Mr. Washburn sold the island to Arthur Vining Davis, head of the Arvida Corporation. This photo is an aerial view of the Honeymoon complex, *c.* 1941.

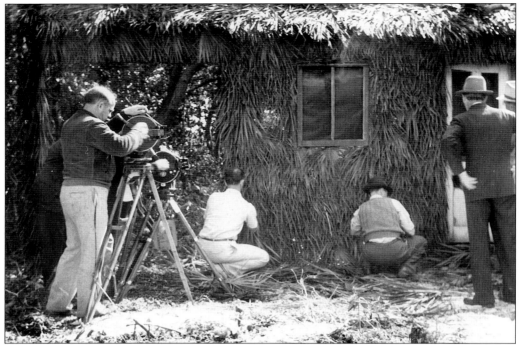

In January 1941, the Paramount-Pathe movie company filmed the honeymoon cottages for one of their news segments.

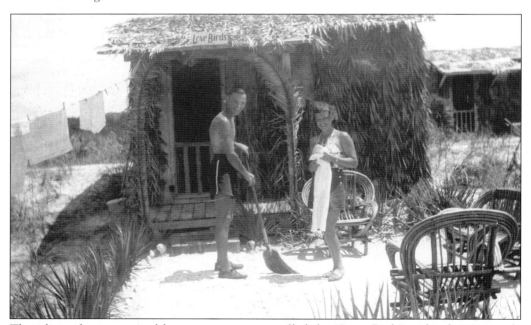

This photo shows a typical honeymoon cottage called the "Love Birds" with a happy couple in front. The first couple to arrive at Honeymoon Island was Marjorie and Ernest Burkett of Orlando, on March 8, 1940. When the 1940 season ended some 250 couples from 100 cities had honeymooned on the island.

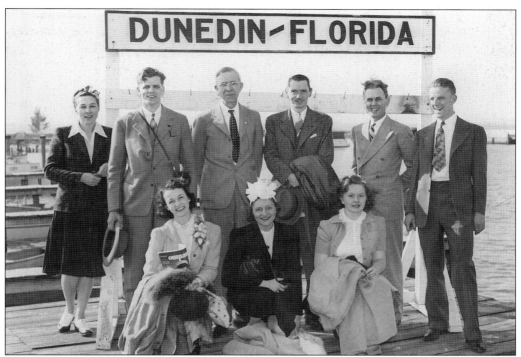

This photo, dated March 14, 1941, shows the first group of honeymooners for 1941 arriving at the Dunedin dock ready to travel by boat to Honeymoon Island. From left to right are: (front row) Mrs. Robert Kerr, Mrs. Thomas Donohoe, and Mrs. Kenneth Nichols; (back row) Mrs. C.M. Washburn, Robert Kerr, Mayor William Titus, Thomas Donohoe, C.M. Washburn, and Kenneth Nichols.

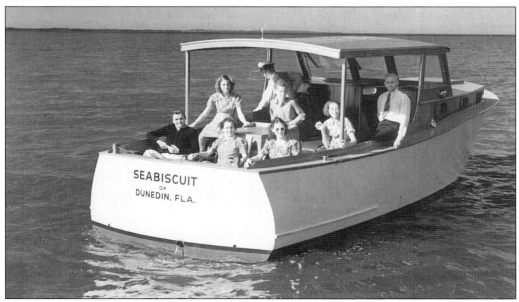

The honeymooners traveled the 2 miles to Honeymoon Island by boat. Most of the honeymooners were ferried over to the island by Al Springer in his yacht called *Seabiscuit*.

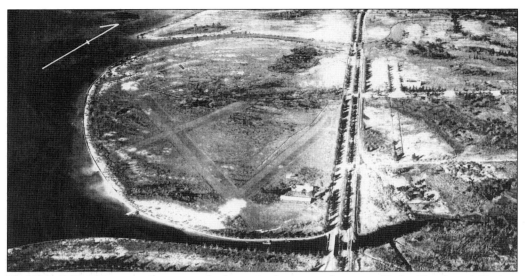

By 1929, B.C. Skinner and partners had acquired property between Cedar Creek and Curlew Creek on the west side of what is now Alternate 19. With the successful flight of Charles Lindbergh, B.C. Skinner decided to use that property to develop Skinner's Skyport. The Skyport was used for flying lessons for local residents, and as a place for Mr. Skinner to store his own personal aircraft. The Skyport lasted until the 1940s, when the U.S. Marine Corps acquired the property for a barracks and training complex. This county aerial photo shows the outline of the Skyport in 1934.

Local flyers took advantage of the Skyport and used it for flying lessons and air shows on Sunday afternoons. W.D. Joyce Jr. and Herbert Meeker posed for the camera in the 1930s.

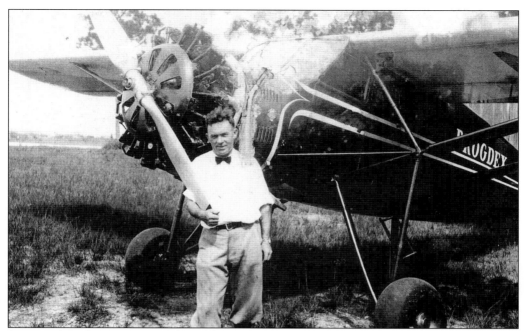

Seen in this photo is Lester Glasscock, posing in front of B.C. Skinner's monoplane aircraft. Lester would assist B.C. Skinner in flying competitions, help maintain the Skyport hangar, and give flying lessons to local residents. In June 1935, when Lester was giving a lesson to W.C. Overcash, the aircraft hit the peak of a house, flipping over and crashing. Mr. Overcash survived the crash, but Glasscock was killed instantly.

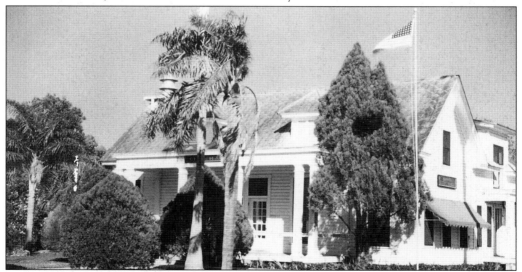

This building, shown here *c.* 1950 and located at the corner of Highland and Virginia, served Dunedin in many ways. The building was constructed around 1895 and was originally used as a school. Parts of the structure came from the original Andrews Memorial Church in the Dunedin Cemetery. From 1915 to 1958 it was used as city hall. It also served as the headquarters for the Dunedin Police and Fire Department. The building was torn down in 1964.

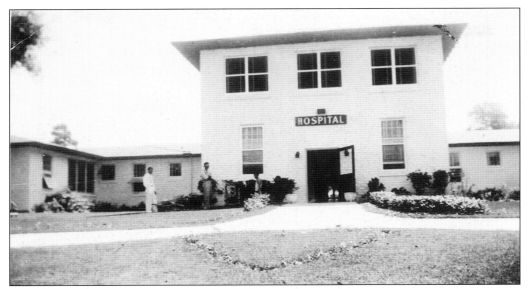

This is a view of the original Mease Hospital Building after its completion in 1937. The hospital was equipped with 19 beds. The 10-acre property, which was originally the sandlot baseball field for Dunedin youth, was purchased by Dr. John Mease.

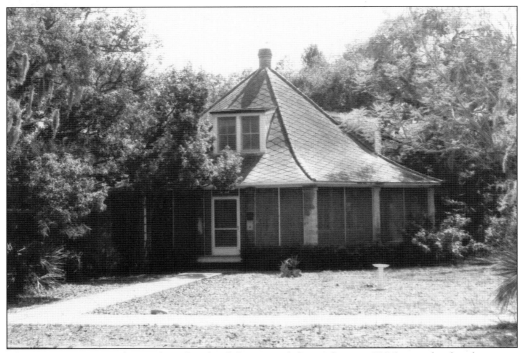

The Octagon House, located on Scotland Street and shown here c. 1995, was the first house in Dunedin to be constructed of masonry blocks, which were made on the premises. It was built in 1900 by Walter Bull, a former mayor of Dunedin. The house still exists today.

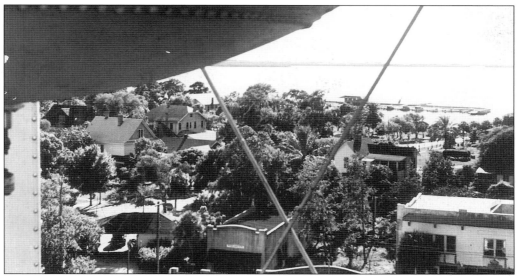

In this 1930s aerial view looking southwest from the Dunedin water tower, the building on the lower left side is the old Dunedin Post Office on Broadway.

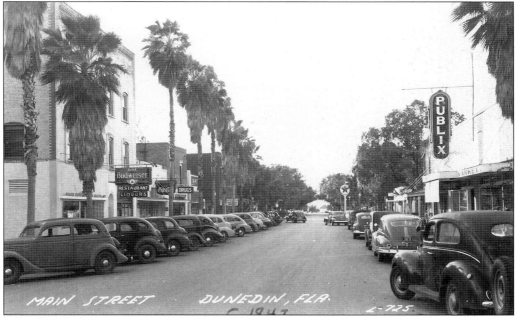

Dunedin's first "super" market was the Publix Market on the north side of Main Street. This market and the name Publix were owned by W.E. "Ed" Humphrey. He eventually sold the name and rights to Mr. George Jenkins of Winter Haven, who owned several other food stores and developed the Publix Markets food chain in Florida. This photograph was taken in 1947 looking west on Main Street towards the Dunedin City Dock. Note how parking was diagonal on the south side and parallel on the north side.

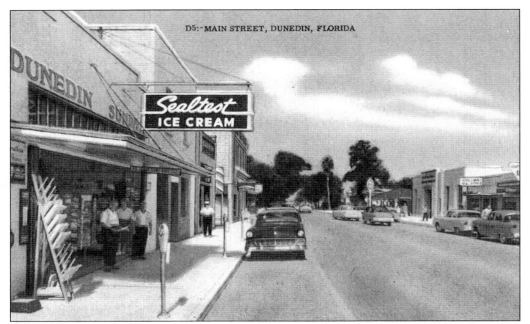

This is an early 1950s postcard view of Main Street looking west. At the end of Main Street on the right side is the Bank of Dunedin and the Texaco Gas Station. In the left foreground is Dunedin Sundries, a drugstore and ice cream parlor.

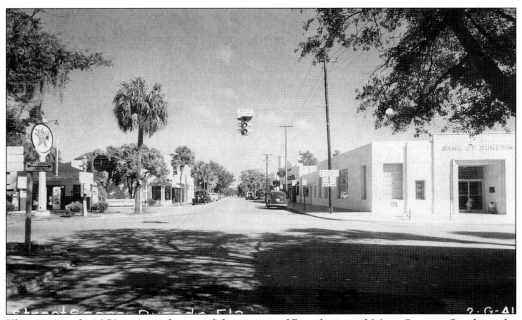

This is an early 1950s postcard view of the corner of Broadway and Main Streets. On the right corner is the Bank of Dunedin, which had moved across the street from the original brick building on the opposite corner. Dorothy Douglas purchased the original bank building and used it as an office for her real estate business.

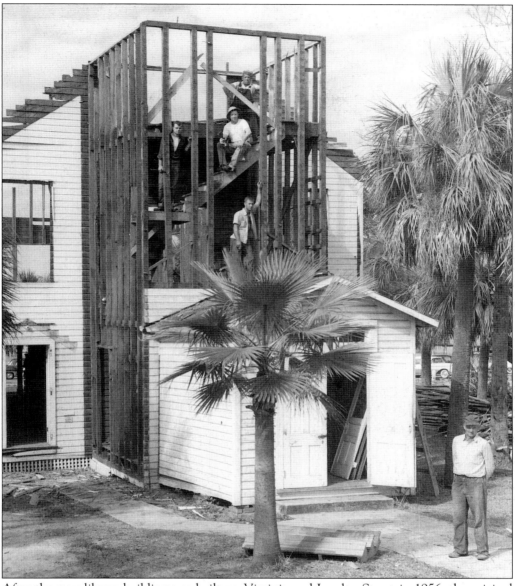

After the new library building was built on Virginia and Louden Street in 1956, the original Library Hall was dismantled and removed from Edgewater park.

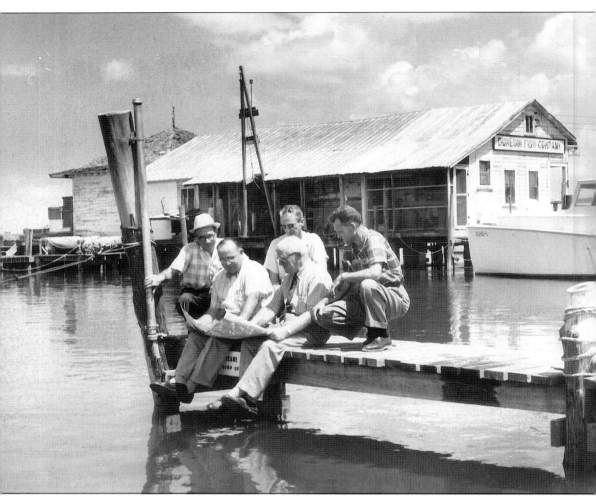

City planners discussed the blueprints for the new yacht basin in the late 1950s. From left to right are Bert Powers, Lewis Earl, Ed Brandenberg, City Manager Herbert Dear, and Douglas Davis. The building in the background is the Dunedin Fish Company.

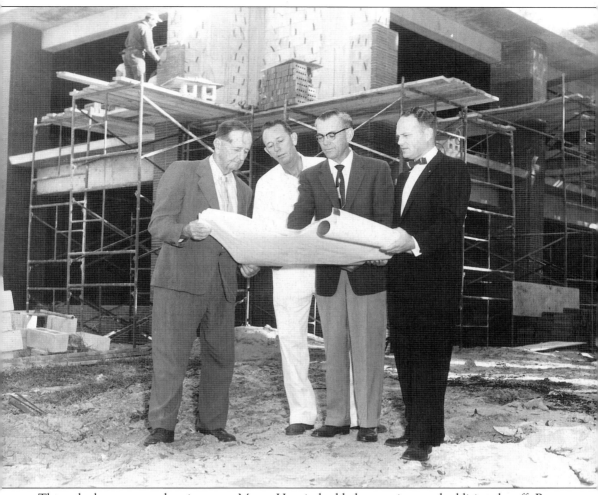

Through the years, as the city grew, Mease Hospital added new wings and additional staff. By the 1970s a major expansion was initiated. Here Dr. Mease (second from right) speaks to city planners and designers about the work in progress.

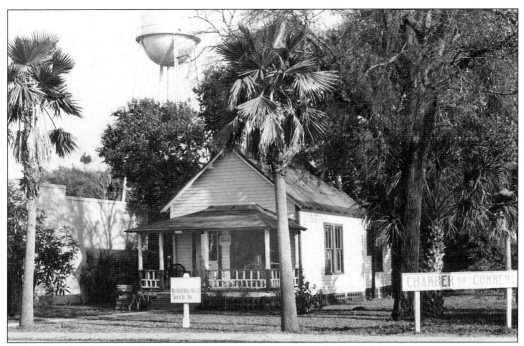

From 1938 to 1947, the Chamber of Commerce headquarters was located on Main Street, across from the railroad station. M.W. Moore had also used that building for his real estate business. Cafe Alfresco Restaurant is located there today. In this 1940s photo, notice the Dunedin water tower in the background.

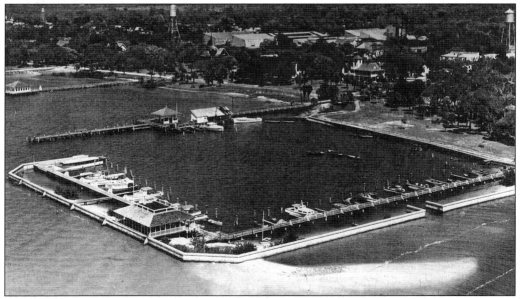

An aerial view of the Dunedin Marina taken in the early 1940s is shown here. The Dunedin Boat Clubhouse was completed on the marina's west wall in 1938. Other sites in the background include the Skinner Machinery Company and the Orange Concentrate Plant, to the far left.

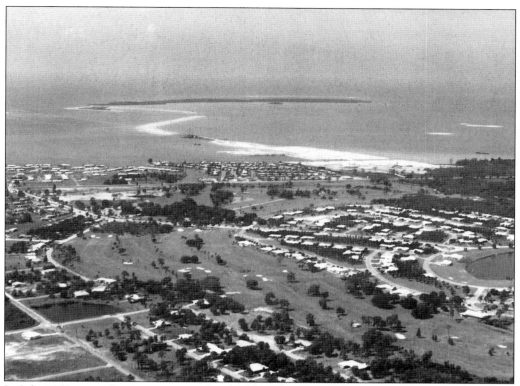

In July 1958, an ordinance was passed to build a $2 million-toll-free causeway to Honeymoon Island. On December 7, 1964, the causeway was completed. On December 18, 1974, the Florida Cabinet voted 5-1 to buy Honeymoon Island. It is now a state park.

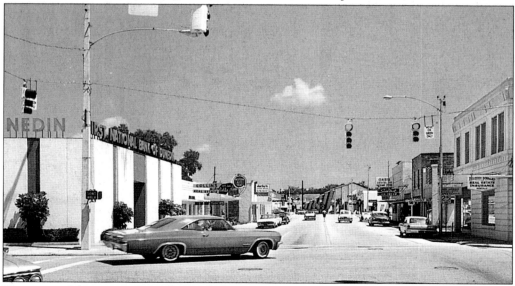

This view of downtown Dunedin, with the First National Bank of Dunedin on the left corner and Dorothy Douglas Real Estate office in the former Bank of Dunedin on the right corner, was taken c. 1967.

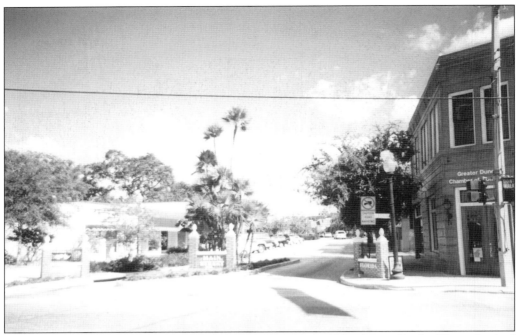

This is a view of the present-day Dunedin downtown district. The former Bank of Dunedin (red brick building) is now the Chamber of Commerce building.

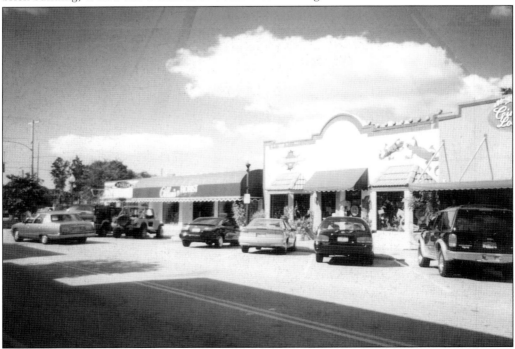

This is a view of some of the local shops in the present downtown district, 1998. Colorfully designed shops include restaurants, antique stores, florists, art galleries, jewelry stores, and children's stores.

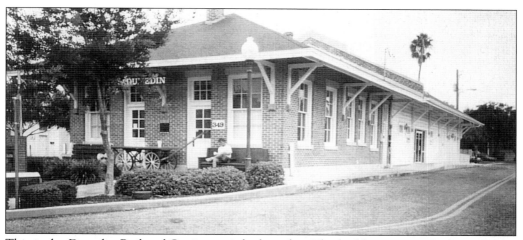

This is the Dunedin Railroad Station as it looks today. The building is now the home of the Dunedin Historical Society. The museum contains collections of photos and artifacts related to Dunedin and Florida history.

In 1996, the new Dunedin Public Library opened adjacent to the old library facility. The old library building was torn down, and plans are underway for the city to utilize that property.

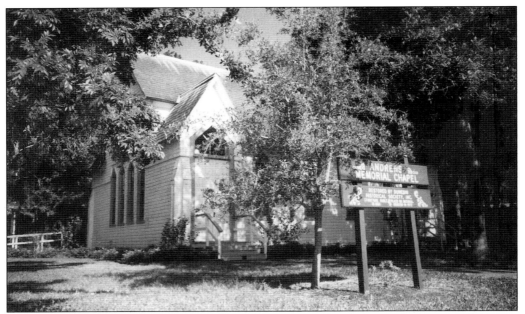

In October 1970, Andrews Memorial Chapel was moved by the Dunedin Historical Society from its location on Highland Avenue to Hammock Park. The Chapel (built in 1888) is now on the National Register of Historic Places and is maintained by the Society, which uses it for concerts, lectures, and wedding rentals.

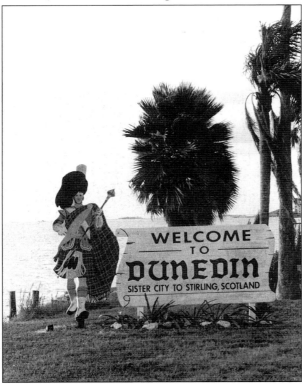

Welcome to Dunedin! This is the entrance sign to Dunedin from Clearwater.

Three

SCHOOLS AND
ORGANIZATIONS

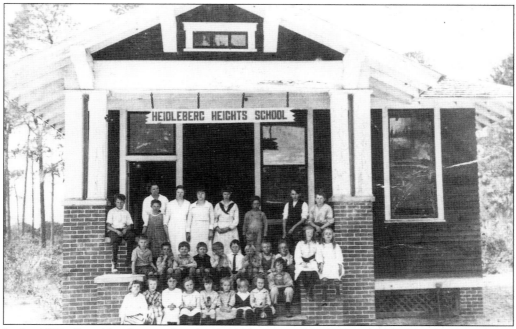

In the 1880s, Rev. Nigels started a school at the corner of County Road 1 and Michigan Avenue. He later donated this land for use as a public school. The school was a small wooden structure that was named in honor of Rev. Nigels's alma mater in Germany. In 1915 the original building was replaced by the neat frame and brick building seen in this photo. The school operated until it burned in 1925.

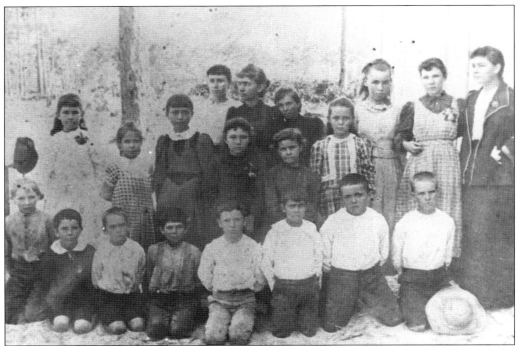

The Dunedin Central School was located in the general area of upper Virginia Street. The school started in the 1870s and was the only public school serving Dunedin proper until 1895. It was listed as School No. 13 in the Hillsborough School files. This photo is of the school class of 1890.

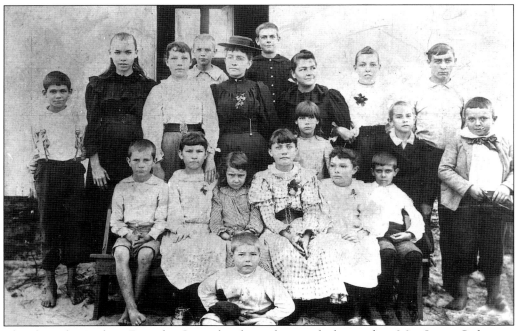

The class of 1894 from Dunedin Central is shown here with the teacher, Miss Jenny Criley.

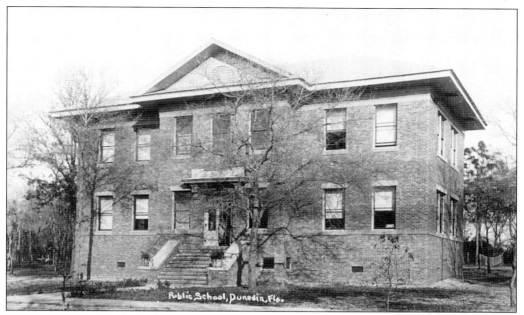

The Red Brick school was located on the corner of Wood Street and Louden Avenue. Until 1926, when a junior high school was built, it contained eight grades in its four classrooms. For 65 years, Dunedin children attended this school. It was razed in 1978.

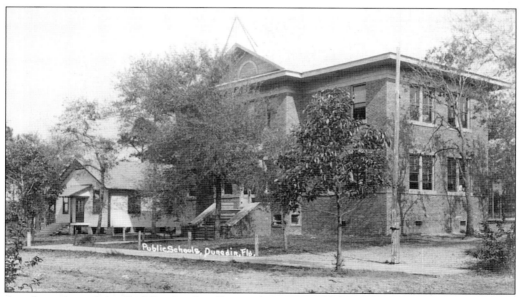

Another view of the Red Brick schoolhouse shows a small frame building to the left of the schoolhouse. This small annex was moved across to the other side of Louden Avenue and is now the home of the Scottish American Society. The entire school property is now occupied by the Sheriff's Department and the City of Dunedin Administrative Building.

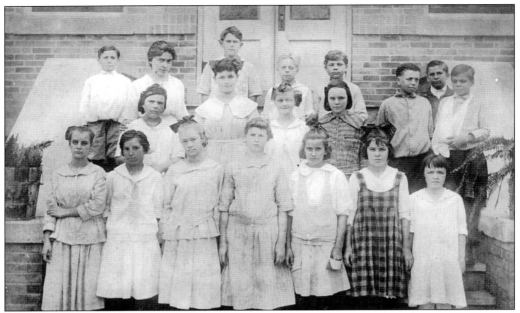

Seventh and eighth grade students were photographed in front of the Red Brick schoolhouse c. 1915.

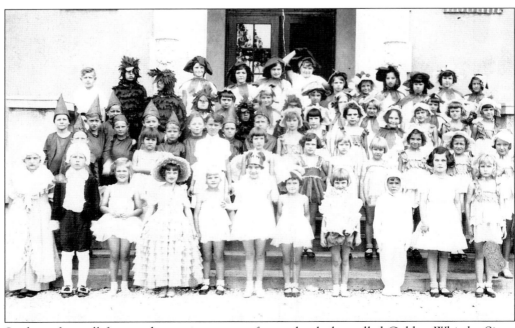

Students from all four grades are in costume for a school play called Golden Whistle. Since there was no auditorium in the schoolhouse, the play was presented on the stage at Library hall. The photo was taken around 1934.

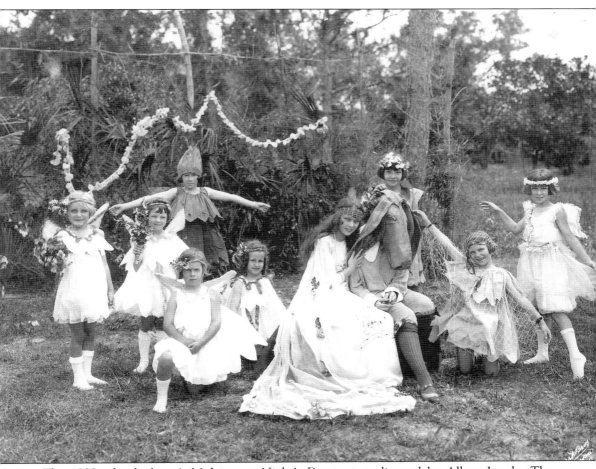

The 1922 school play, A Midsummer Night's Dream, was directed by Albert Lando. The cast includes, from left to right, Peggy Armston, Charlie Mae McMullen, Jane Tharin (rear), Mildred Powers (front), May Beth Goss, Mary Mildred Smith as "Titania," Dorothy Rhoden (behind donkey), Dorothy Lord, and Vivian Skinner.

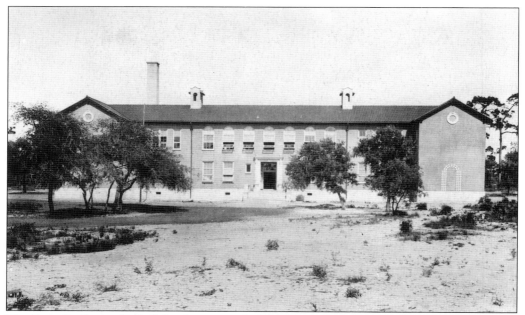

The Dunedin Junior High School was completed in 1926 and housed grades five through nine. Located on the corner of Beltrees and Milwaukee, it is now Dunedin Elementary School.

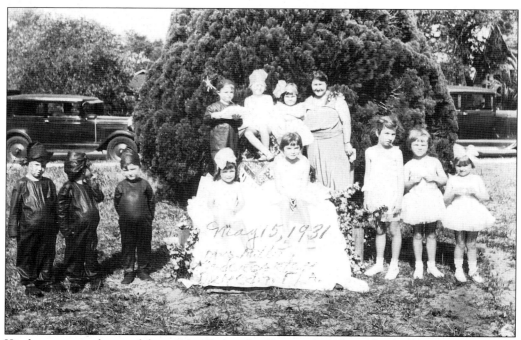

Kindergarten students celebrate May Day with a Fairy and Elf festival. This photo was taken on the Speir family lawn on Highland Avenue c. 1931.

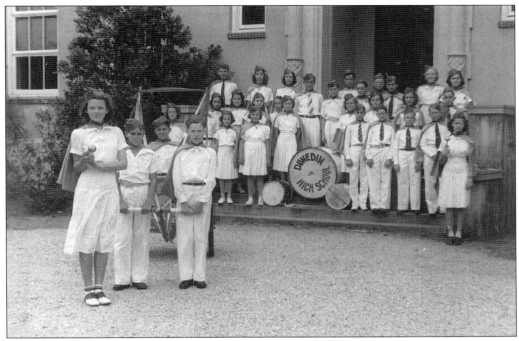

The Dunedin Junior High School Band was photographed in 1938. The Drum Major was Martha Jane Hotchkiss.

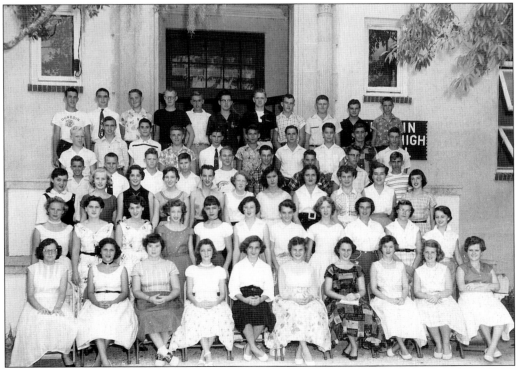

The Dunedin Junior High School students posed for this class picture in the 1940s.

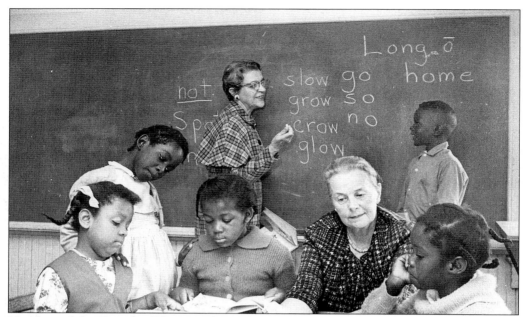

Members of the Dunedin Educational Enrichment Program (DEEP) are shown here, c. 1964. Located in the old Chase Memorial School, volunteers joined Mrs. Herbert Leland to provide tutoring and a cultural program to help students from segregated schools bridge their educational gap.

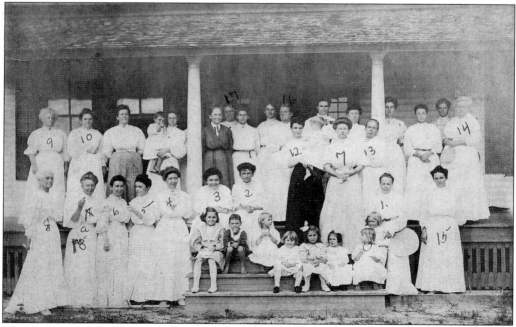

There were many activities within the community of Dunedin for men, women, and children. Ladies of the community posed in 1915 after attending the Village Improvement society meeting. The woman labeled No.3 was Mrs. Edna Hope Trask, who would become Dunedin's first "Postmistress," attending to the U.S. post office.

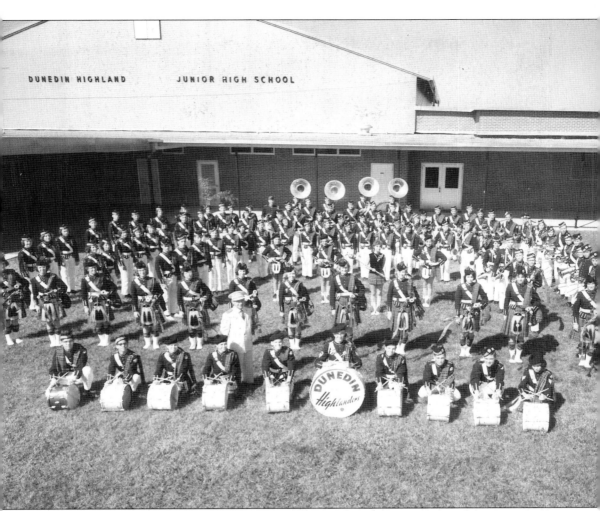

Dunedin Highland Middle School, formerly Dunedin Highland Junior High, is located on the northwest corner of Union Street and Patricia Avenue. Their logo, uniforms, and bagpipes echo Dunedin's Scottish heritage.

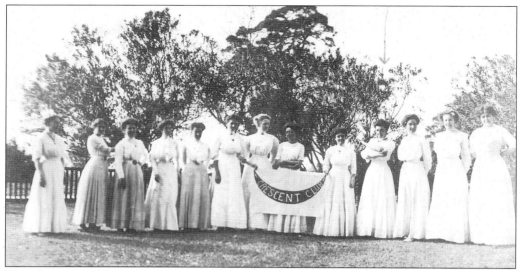

The "Crescent Club" was a young girls' organization in Dunedin in the 1890s. Girls would read plays, go camping, and hold picnics. In this 1890s photo, the club poses for a group assembly in front of the Skinner home on Victoria Drive.

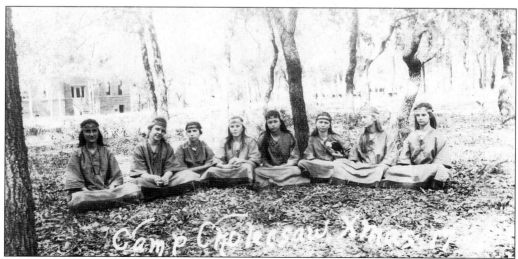

Campfire girls posed during an Indian camp-out in 1917. The Dunedin Elementary School is in the background.

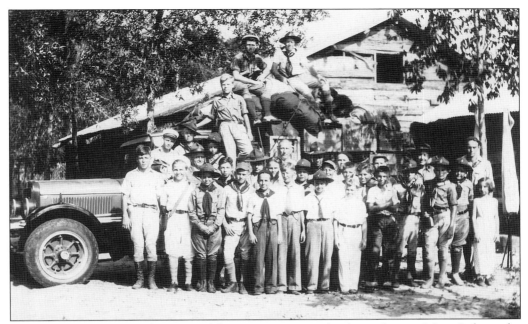

Dunedin Boy Scouts posed in front of the camping van used to bring them to Moon Lake in the 1930s. The scoutmaster was Mr. Troutman.

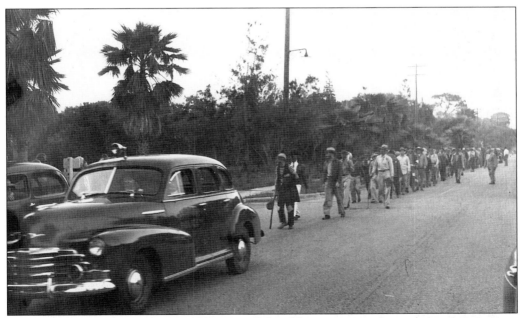

The Dunedin Masonic Lodge No.192 is one of the oldest continuously operating organizations in Dunedin. One of the special functions the Masons held was the annual Hobo parade in downtown Dunedin. As shown in this 1940s picture, the members would dress up like hobos and parade through town, then have a lunch of Mulligan stew and very strong coffee and have a contest for the best costume.

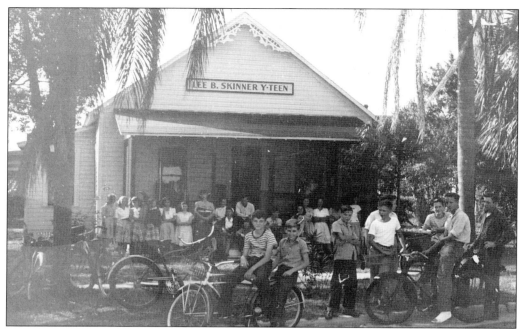

In the 1950s Elizabeth Skinner Jackson was so upset that children did not have a center for recreational activity that she donated two of her property lots, one of which included a building, to build the Lee B. Skinner Youth-Teen Center.

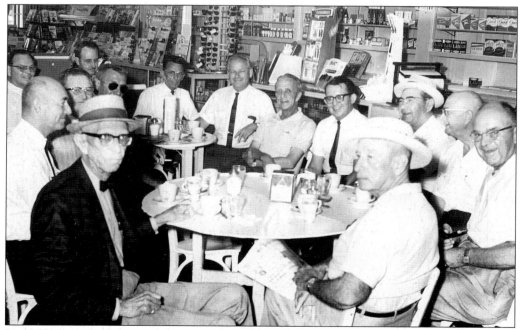

In 1955, several of the men living in Dunedin including Mayor Sam Davis, William Dicus, William Dexter, and Robert Grant, started to meet for morning coffee at Dunedin Sundries and discuss local politics and community activities. They named their organization the Dunedin Kaffee Klatsch, and a growing group of men have been meeting on a daily basis since that time.

Four

POLICE, FIREMEN, AND POSTAL SERVICES

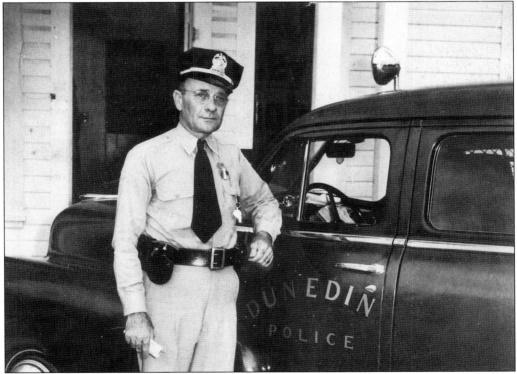

In 1944 the Dunedin Police Department consisted of Chief George Davis and two police officers, one of whom was Eugene Sheets (seen in this 1940s photograph), who took over as chief in 1948. Chief Sheets was highly respected by all residents of Dunedin. He retired in December 1967, after 19 years as chief.

In the 1950s, the Dunedin Police force hired a black officer to patrol the black community. Here, Mr. John Evans, in uniform, poses with his wife.

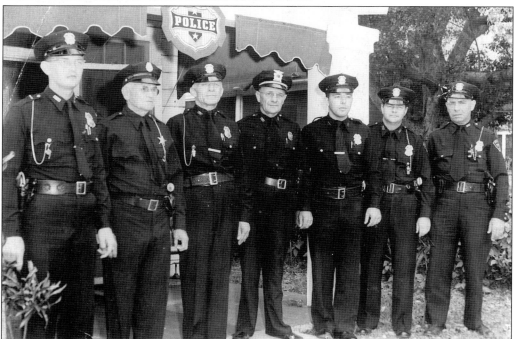

In the spring of 1953, Chief Sheets moved his four-man, one-patrol-car department from a back room of city hall into a modern new 12-by-12-foot police station located at the southwest corner of Main Street and Broadway. This photo, taken in 1956, shows the department had increased the number of police officers on the force since 1953.

By 1959, the Dunedin Police Force had its first and only motorcycle police officer. The officer assigned to this duty was Bobby Ayers, seen in this photograph.

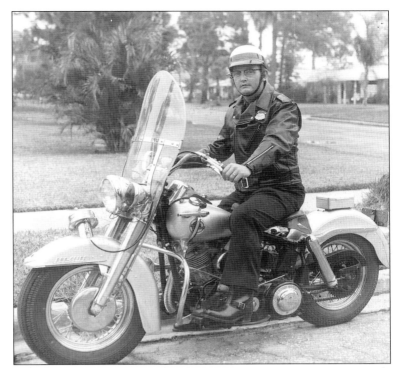

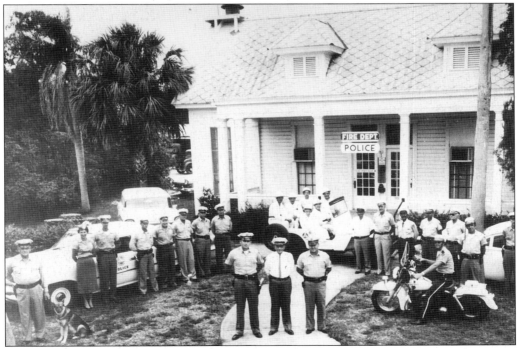

In 1958 the police department took over the entire city hall building at Main and Virginia as their headquarters. It was also shared by the Dunedin fire department. This picture was taken c. 1959.

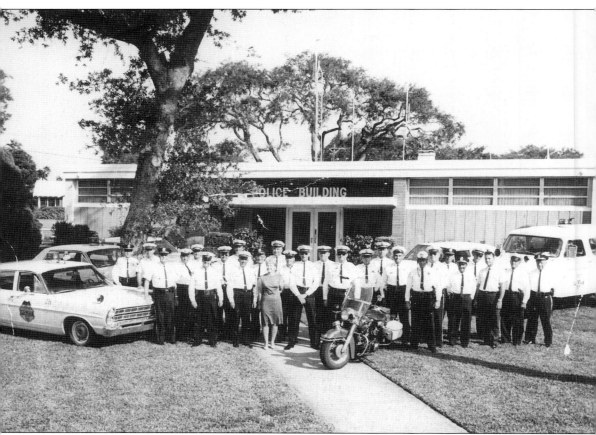

The police department moved two more times between 1960 and 1995. In this 1960s photo, the police department stands in front of their facility, which was the old library building at Virginia and Louden Avenue. The Dunedin Police Department continued to grow until October 1995, when the city began utilizing the services of the Pinellas County Sheriff's Department.

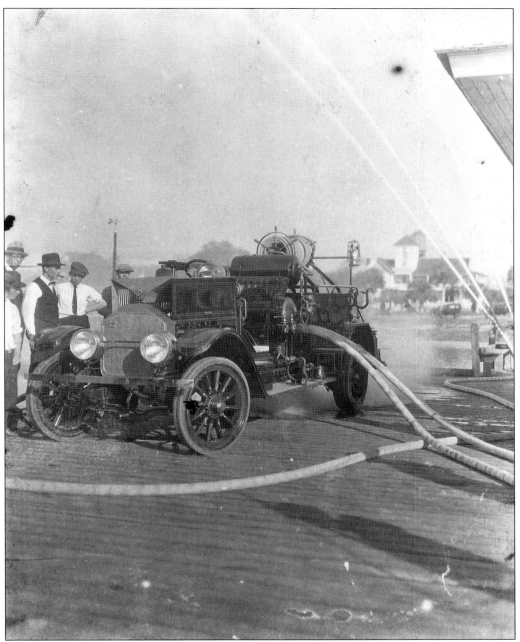

The Dunedin Fire Department was organized in 1913. At that time the department had 14 volunteer firemen and a Model T fire truck. In 1922, Henry Houghton was appointed fire chief, a position he held until 1945. A 1922 American LaFrance fire truck was purchased for $12,500. It arrived in February 1923 at the Dunedin railroad station and was immediately tested, as seen in this photograph taken at the Dunedin City Dock. Smoking the cigar is Fire Chief Henry Houghton.

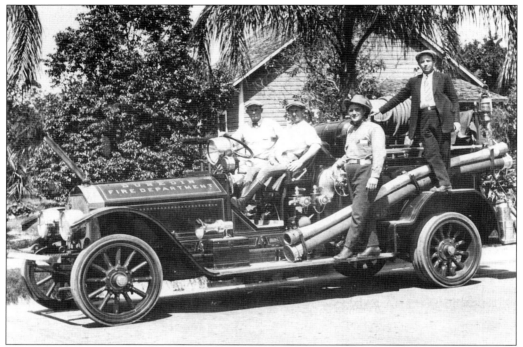

This 1923 photo of an American LaFrance fire truck was taken on the west side of Broadway, just south of Main Street. From left to right are, Rhada Chalk, Fire Chief Henry Houghton, and volunteer firemen Pirkle and Becker.

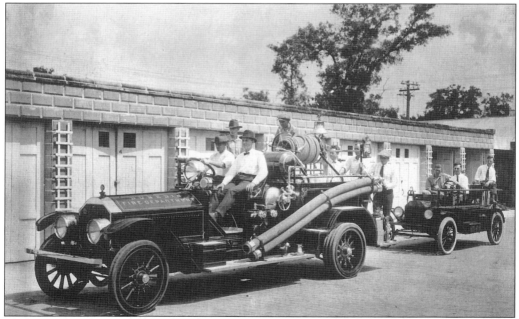

Dunedin's fire trucks line up ready for inspection. The lead fire truck was Dunedin's purchase in 1923. Chief Houghton is sitting next to the driver. The other fire truck was Dunedin's first, a Ford Model T. (Courtesy Pinellas County Museum.)

In 1878, the first Dunedin Post Office, pictured here in 1889, was established in the Douglas and Somerville General Store in what is now Edgewater Park. James Somerville was the first postmaster and held that position until 1889. By 1885 mail was arriving at the Dunedin dock three times a week.

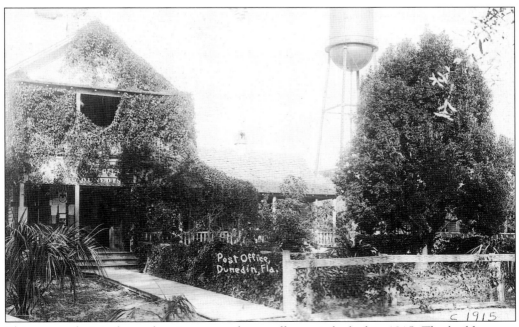

This postcard view shows the vine-covered post office as it looked in 1915. The building was located near the corner of Broadway and Main Streets.

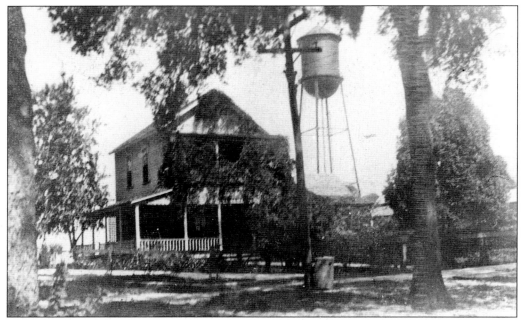

Another view of the Dunedin Post Office was taken c. 1920. Mrs. Edna Hope, Dunedin's first postmistress, served from 1902 to 1929. The post office was housed in Mrs. Hope's home.

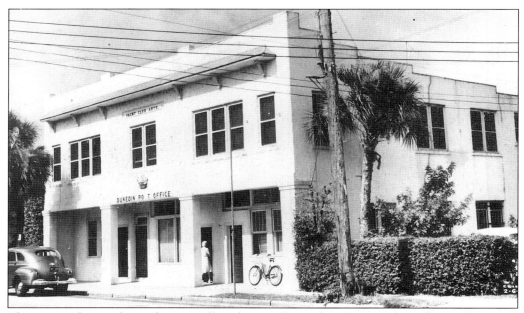

This postcard view shows the post office that was located at 826 Broadway during the 1930s. After the post office moved to a different address, the building became an apartment complex and later the office of attorneys Peebles and Gracy.

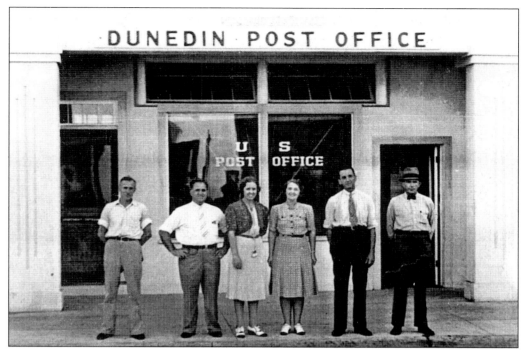

Here, postal employees stand in front of the Broadway Post Office in the 1930s. From left to right are, Pat Laursen, Bernie Grant, Edith Grant, Mrs. Edna Hope, J.R. Williams, and Mr. Brown. Mr. Brown would be the first full-time regular mail carrier in Dunedin.

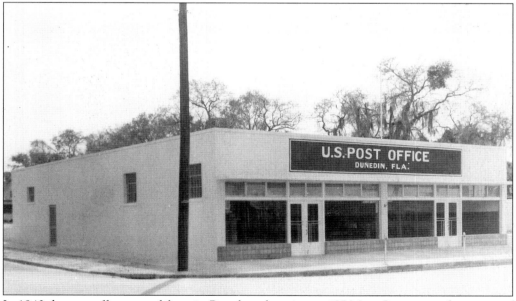

In 1940 the post office moved from its Broadway location to 487 Main Street near the corner of Highland Avenue. This photo shows the newly completed building.

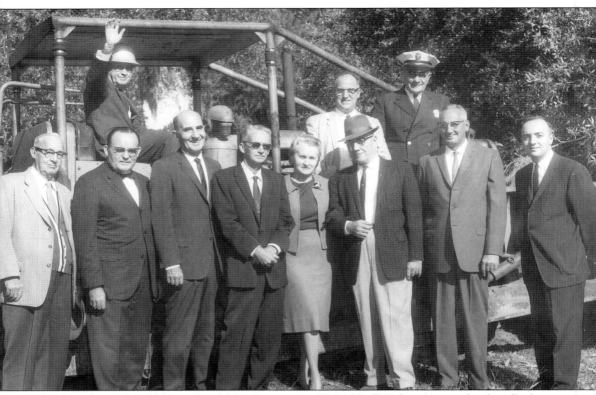

In this photo, dated November 1962, Postmaster W.A. (Bud) Fisher (raising his hand) along with other city officials, celebrates at the groundbreaking ceremony for the new post office located at 592 Main Street. In 1983, the post office moved again to its present location on County Road 1.

Five

SPORTS AND RECREATION

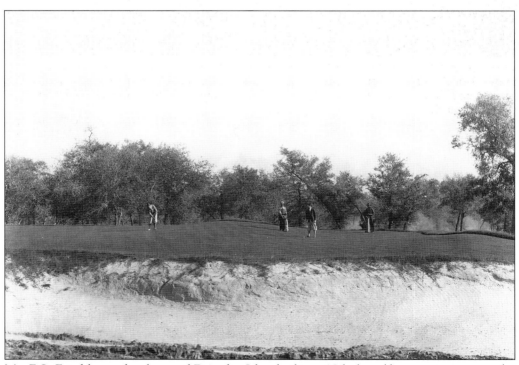

Mr. E.S. Frischkorn, developer of Dunedin Isles, built an 18-hole golf course to serve as the centerpiece for his development. The course opened on January 1, 1927. When the Florida land boom went sour, the golf course was taken over by the City of Dunedin. This photo of players on the golf course was taken shortly after the course opened.

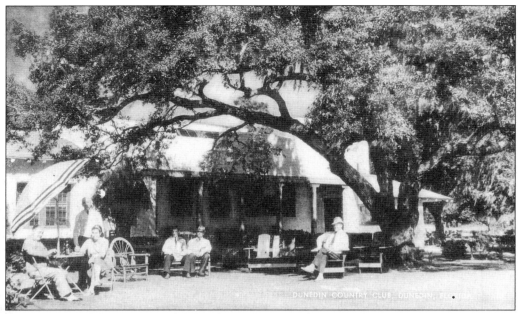

This is a view of the Country Club building, which was the former home of Baron Otto Quarles van Ufford. A new $150,000 clubhouse was promised, but the Great Depression stopped the plans. Many celebrities would use the golf course, including Babe Ruth, who was at St. Petersburg for spring training.

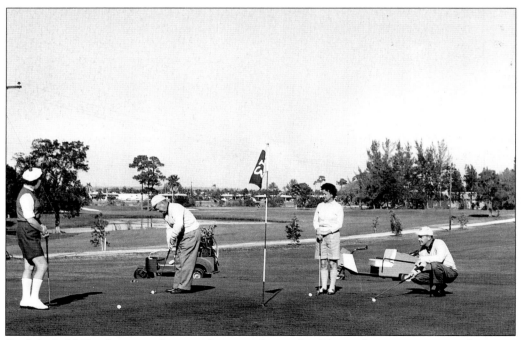

On July 9, 1962, after several proposals were submitted, a 30-year lease was given to the group known as the Dunedin Country Club. The club improved the golf course and built a new clubhouse. After 34 years that clubhouse was razed and a new one built in 1997.

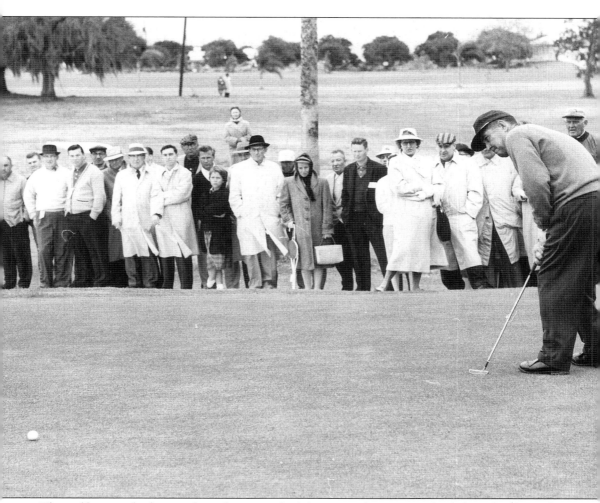

The golf course had gone through a period of disrepair when it was deeded to the City of Dunedin in 1938. With WPA funding, the necessary funds were raised and play on the course was resumed.

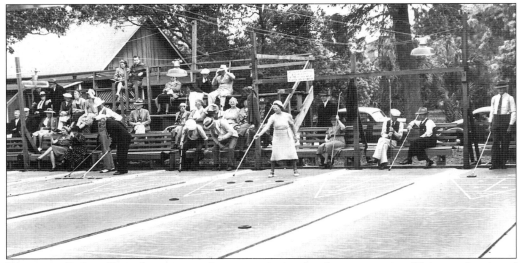

Edgewater Park in Dunedin contained many activities for the community. This was the site of Library Hall and the recreational area for residents to enjoy tennis and shuffleboard courts. A shuffleboard club was organized in 1935 and grew to a membership of over 450 members. The shuffleboard and tennis courts were eventually removed to make a playground for children. The photo shows a large group of Dunedin residents and tourists enjoying a game of shuffleboard in the 1930s.

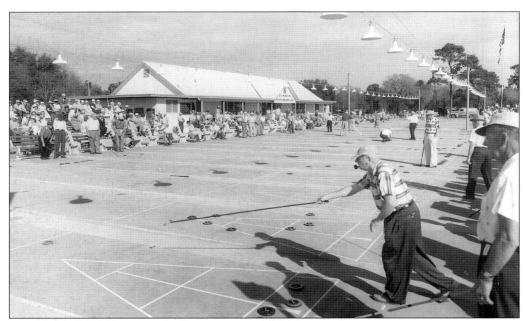

After the shuffleboard courts were removed from Edgewater Park, a new facility, shown here in the 1960s, was built on Douglas Avenue across from Grant Field. Tournaments and various shuffleboard events are held here.

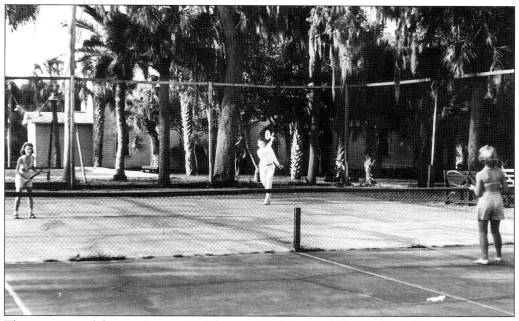

This is a view of the tennis court in Edgewater Park in the 1930s. Behind the tennis courts is Library Hall.

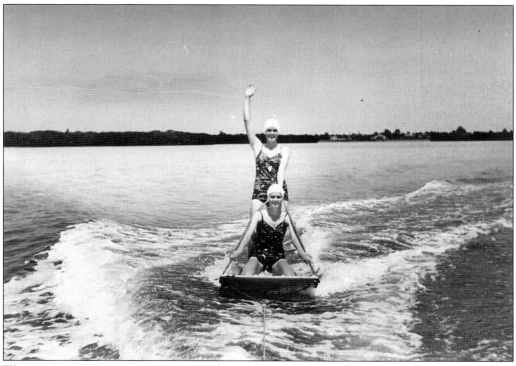

Water sports were an important part of Dunedin's recreational activities. The Crisman twins Myra (standing) and Mary enjoyed water boarding in the 1930s.

Fishing around the Dunedin area was especially popular. Here a tourist shows off his catch for the day on the fish rack at the City Dock, c. 1940.

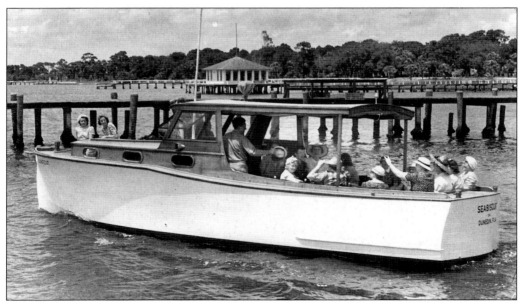

Boating and sailing have always been popular in Dunedin. The marina contains many types of boats for recreational uses. In this photo, Al Springer, in his boat called Seabiscuit, takes tourists and friends for a cruise on St. Joseph's Sound in the 1940s.

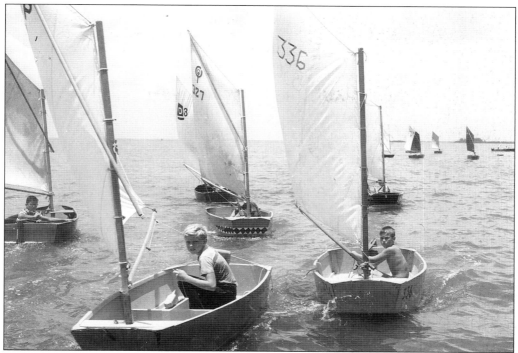

Children of Dunedin have also been involved with sailing. In 1949, with the help of the Optimist Club and boat designer Clarkie Mills, a sailing vessel was built to teach children how to sail. The "pram"-style boat is 8 feet long, flat-bottomed, and has a simple mast. Robert Longstreet and many other volunteers helped to organize a Dunedin Pram fleet. The vintage years of the Dunedin Pram fleet were from 1949 to 1961. A Pram fleet storage facility was built next to the Dunedin Boat Club in 1958.

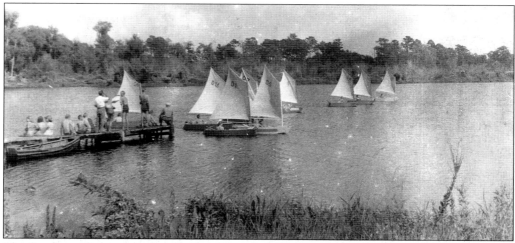

The first State Pram regatta was held in Dunedin in 1952. The weather was very rough and the waves too choppy in the boat basin, so the regatta was held on Jerry Lake. The photo shows the start of the first round of the State Pram races. Winners included Phyllis Douglas, Jackie Longstreet, Dennis McHale, Florence Cloud, Harry Nelson, and Raleigh Thomas. (Courtesy of Phyllis Douglas.)

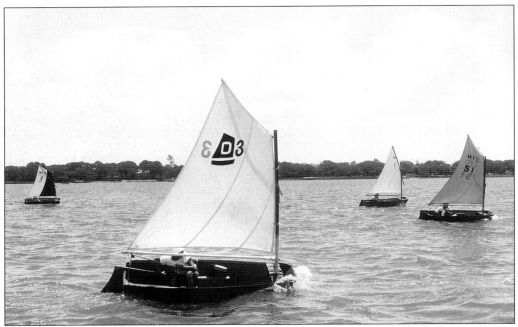

The pram seen in this *c.* 1950 photo has the Dunedin Pram Fleet logo on its sail.

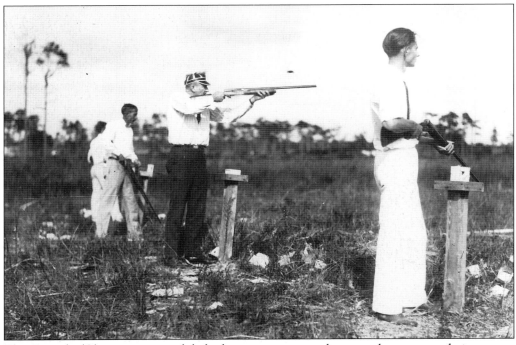

The Dunedin/Clearwater gun club had many unexpected guests show up at their events. In this photo, baseball player Dazzy Vance visits during spring training to try his hand at target shooting.

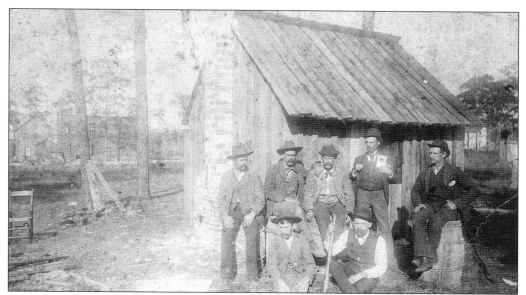

One of the first photos showing Dunedin's early interest in baseball was taken in the early 1880s. It shows seven of the team members posing after a game of "townball." Captain Fred Emerson (top row, second from right) displays the scorecard. Home plate is to the left of the group, and a bottom row team member holds the bat.

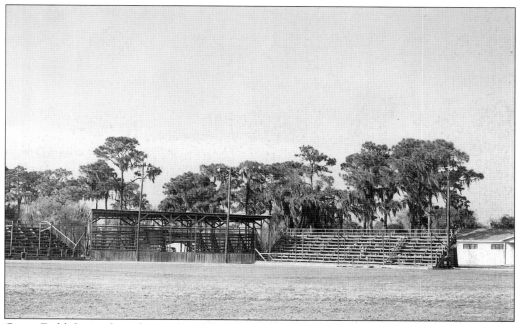

Grant Field, located on the corner of Douglas and Beltrees, was dedicated to A.J. Grant in the 1930s. The ballpark, shown here as it appeared in the 1930s, was built as a WPA government project. The complex has undergone numerous improvements and hosts the Toronto Blue Jays and Florida State Baseball League.

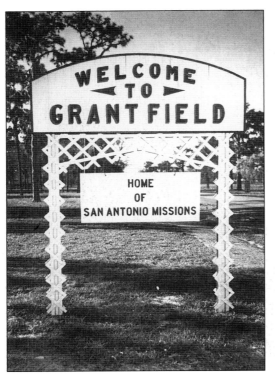

This is an early entrance sign to Grant Field, shown in a 1950s photo. The Toronto Blue Jays, who use the complex at present, are not the only baseball organizations to have used it. Minor league teams such as the San Antonio Missions and AA Buffalo Bisons have also used this field as a training facility. It is also used by the Falcons, Dunedin High School's baseball team.

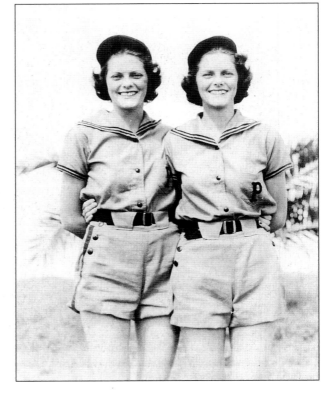

Twin sisters Mary and Myra Crisman were very involved in athletic activities in Dunedin. Here, the pair is dressed in their softball uniforms for the Dunedin/Clearwater team Peggy's Girls. Peggy's Girls would participate in the Women's Softball Championship in Chicago in the late 1930s.

Little League baseball came to Dunedin in 1954. The group behind this project was the Dunedin Jaycees. With the help of community businesses, four teams were established including the Chamber of Commerce, Rotary, Jaycees, and the Bank of Dunedin. Members from each team were given special books to celebrate the opening season games. Edward H. Eckert is in the center.

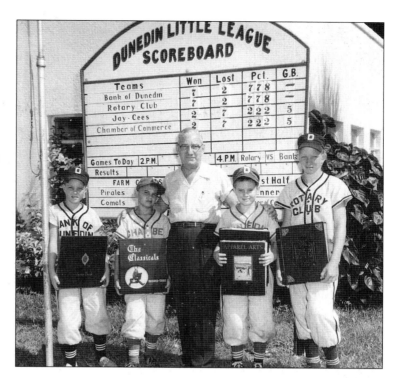

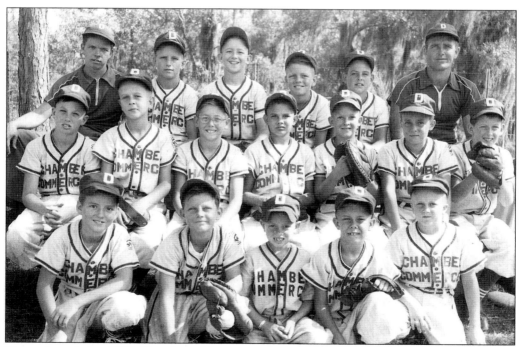

Shown here is the 1955 Chamber of Commerce little league team managed by Carson Woods and coached by James Rains.

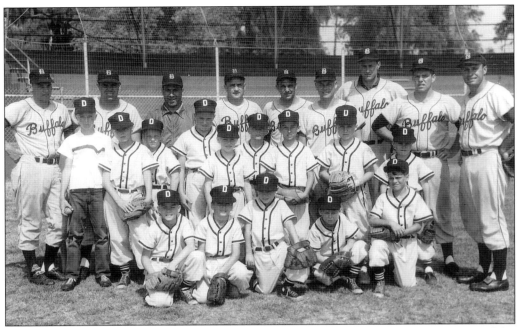

Prior to their last season in Dunedin in 1962, the Buffalo Bisons team poses with some of the boys on the little league team.

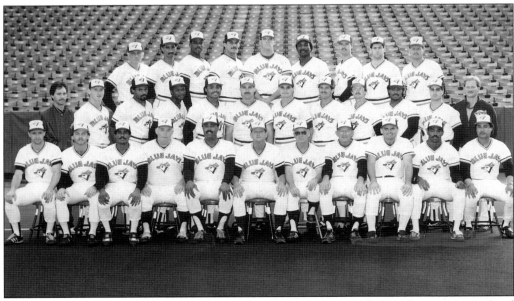

With the help of several prominent leaders in the community including former Mayor Cecil Englebert, the Toronto Blue Jays made Dunedin their spring training facility. The 1977 team photo shows the Blue Jays when they arrived in Dunedin for the first time.

Six

STORES AND INDUSTRIES

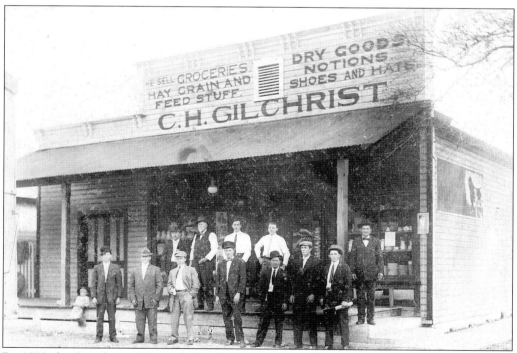

By 1902 the Douglas and Somerville store at the foot of Main Street in Edgewater Park had been sold to Charles H. Gilchrist. Around 1903 a fire destroyed the original building. Mr. Gilchrist built a new store on the northeast corner of Main Street and Railroad Avenue beside the railroad tracks that had recently arrived in town. This photo was taken *c.* 1911. (Courtesy of Dr. Golden.)

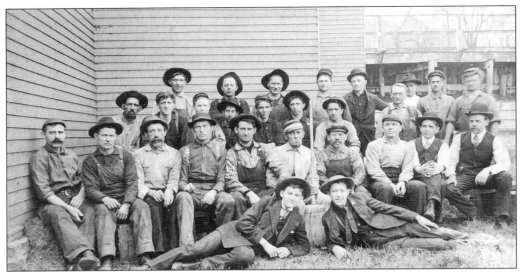

Around 1880, citrus replaced cotton and vegetables as the main commercial crop. The citrus industry then underwent a rapid expansion. All was going well for the industry until the winter of 1894–1895, when the "Great Freeze" occurred, dropping temperatures into the teens and killing many of the trees. Many of the grove owners gave up the groves at low prices and left the area. Those who remained were able to buy up the damaged groves, redevelop them, and eventually make a profit. Grove workers and company officials pose together at the Emerson Grove in the 1890s.

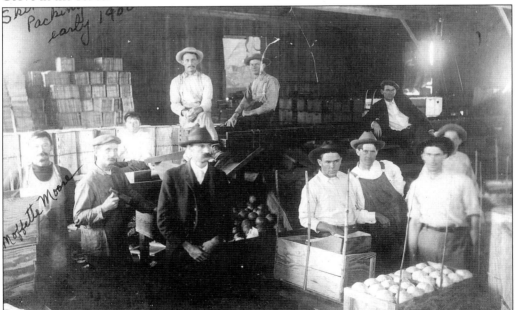

In the early 1900s L.B. Skinner, along with winter resident Mr. C.B. Bouton, bought abandoned groves left from the great freeze of the 1890s. The operation grew, and Skinner hired packers and invented machinery to wash, sort, and grade the fruit. This increased his profits, and he bought out Mr. Bouton's interest. This photo shows the interior of the Skinner packing house in the early 1900s.

By 1913, Mr. Skinner and his son Bronson improved the citrus machinery and incorporated as the Skinner Machinery Co. It became the largest manufacturer of packing house equipment in the world at that time. Bronson ran the machinery company, and L.B.'s youngest son Francis took over the packing house and the groves.

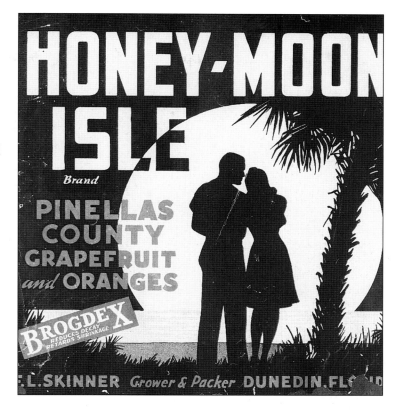

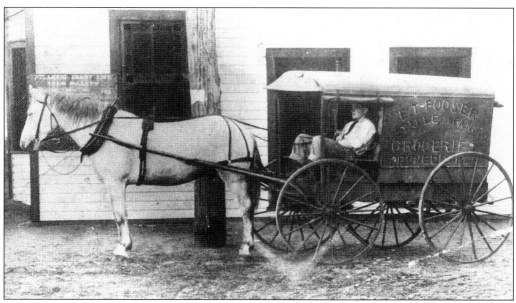

Here, Pooser's Grocery Wagon is shown making grocery deliveries in Dunedin, *c.* 1900. Porter Zimmerman is at the reins.

In the early 1900s, cattle ranching took place near the Andrews property, where Sunset Point Drive ends at Edgewater today. Note Stevenson's Creek in the background.

At one time in Dunedin, celery ranching was a very profitable business. This photo was taken *c.* 1920.

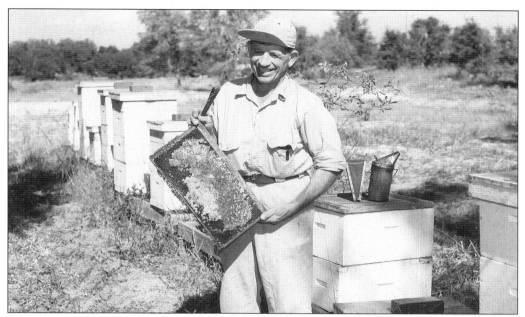

Dunedin residents could take a ride up Milwaukee Street to Main Street and purchase fresh honey from the "Honey House." Here Ross Haines shows off one of the honey combs in the 1930s.

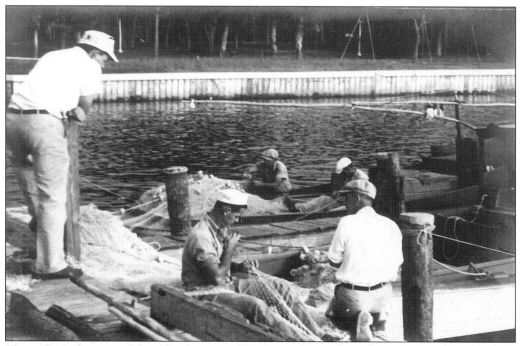

Throughout the years, fishing has been good business in Dunedin. The Dunedin Fish Company, located by the entrance of the Marina, has been in that area for approximately 70 years. This photo shows the fishermen fixing their nets for the next catch in the 1930s.

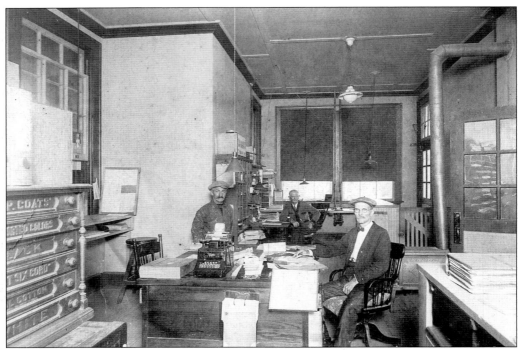

This interior view of one of the stores on Main Street was taken *c.* 1900.

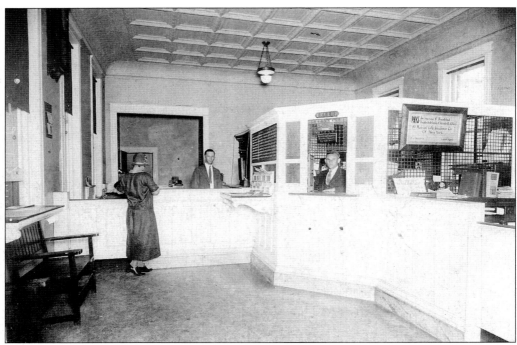

This is an interior view of the Dunedin Bank. The bank opened in October 1913 on the corner of Main Street and Broadway. Employees of the bank are Bert Grant (left) and R. Barclay McMaster. Here, a resident has come in to make a deposit *c.* 1932.

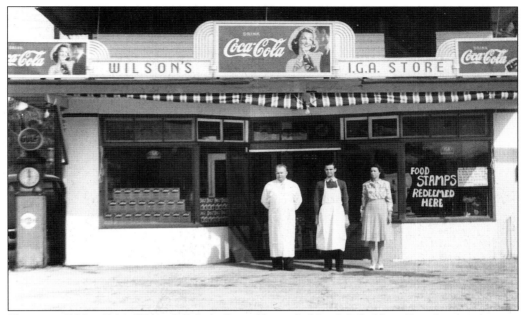

Shown *c.* 1930 at John Wilson's I.G.A. Store (formerly Vitte's I.G.A) on Douglas Avenue are, from left to right, Sheldon Walsingham, John Wilson, and Mrs. Wilson.

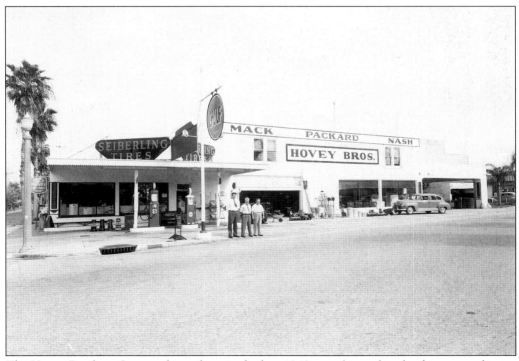

The Hovey Brothers Garage, shown here in the late 1940s, was located in the downtown district of Dunedin. The building was later destroyed by fire.

Located next to the Dixie Theater and first called the Dixie Cafe, the Blue Bird Restaurant was a soda fountain parlor and town gathering place. It is shown here as it appeared in the 1930s.

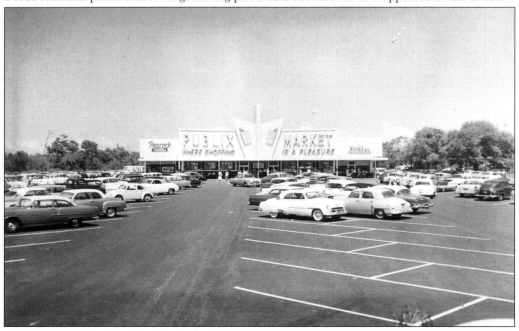

This Publix Chain Store was located on Douglas Avenue, where the new Dunedin Public Library is now located. The original Publix grocery store was located on Main Street in downtown Dunedin. Mr. Humphrey, the owner of the store, sold the name rights to Mr. Jenkins of Winter Haven. This photo was taken in the late 1950s.

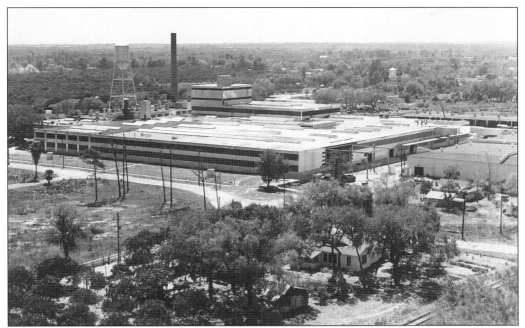

This is an overhead view of the Bronson Skinner's Orange Concentrate Plant, located near Highland and Bayshore. It was considered to be the largest and most modern citrus juice plant in the world when it was built in the 1940s.

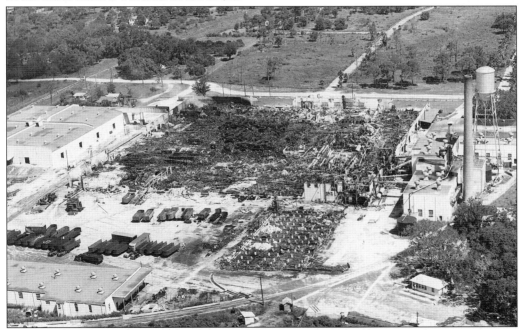

Disaster struck the Citrus Concentrate Plant on the night of August 27, 1945, when a fire broke out and destroyed the main plant and offices. Only a few buildings were saved. B.C. Skinner vowed to rebuild the plant, and he did, but soon after he sold it to Snow Crop, which continued to operate the plant until 1955.

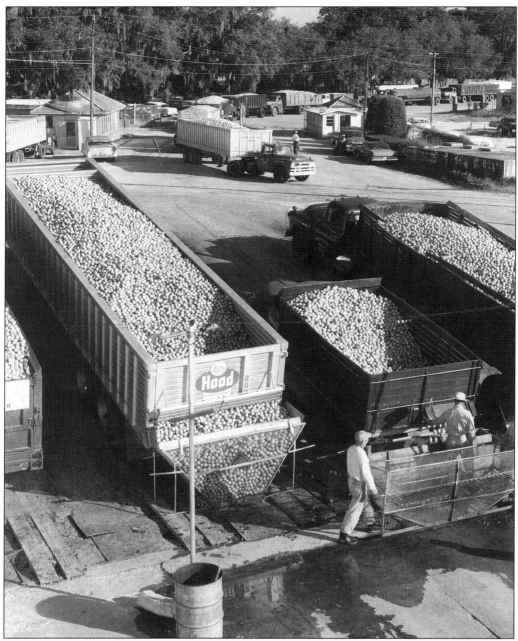

In 1955 the Minute Maid Corporation bought out Snow Crop, and continued to operate the plant until 1956, when Minute Maid moved this branch of the operations to Orlando. They then sold the Dunedin plant to H.P. Hood and Sons. The photo shows trucks unloading citrus for processing into concentrate at Hood plant. Today the company and property have become the property of the Coca-Cola Company.

Seven

DUNEDIN GOES TO WAR

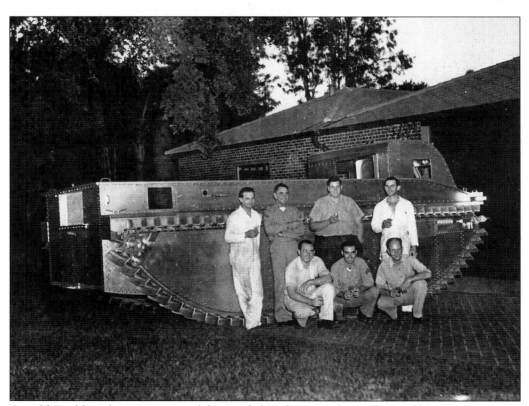

Donald Roebling (rear row, second from right) is shown in front of one of his early creations, the Alligator. These vehicles were initially created as rescue vehicles for hurricane victims until the Navy thought of other potential uses.

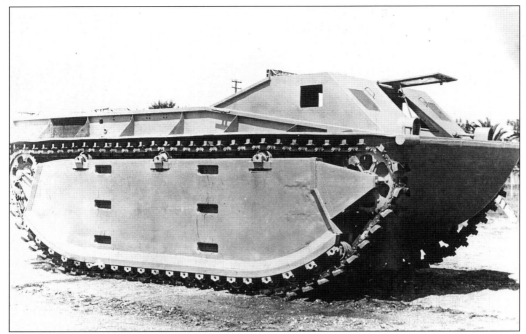

Shown here is a close-up view of a Roebling Alligator. One of a few variations of the Alligator made for the Navy by Roebling, this one is the LVT1 "Amtrac." Many of the vehicles were manufactured by the Food Machinery Corporation (FMC), which had plants in Dunedin and Lakeland.

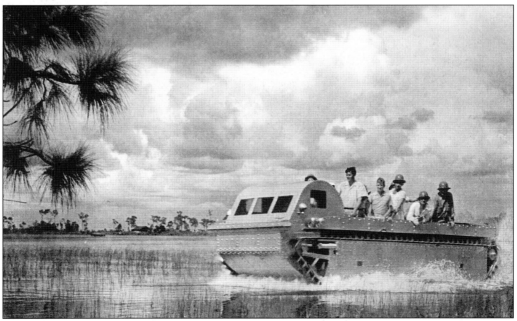

Roebling and some of his staff are seen test driving an Alligator for some naval and marine officers on board in 1940.

A watchtower was added to the roof of Library Hall. This post was manned by Civil Defense volunteers who searched the skies for enemy aircraft. At the same time, the old Dunedin Hotel was converted into a U.S. Marine Barracks.

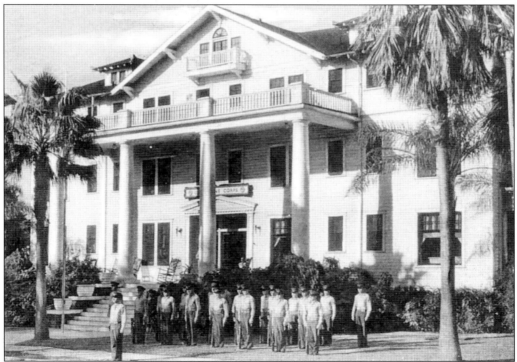

Prior to 1942, the old Dunedin Hotel was converted to a U.S. Marine Barracks. (Courtesy ADEQ Historical Resources.)

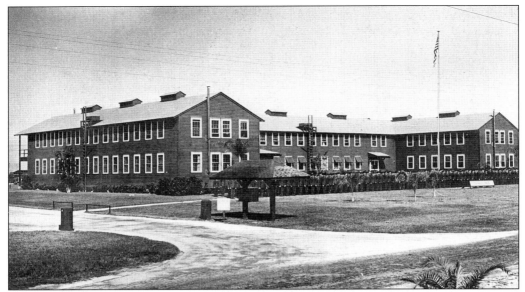

Upon completion of the new Marine Barracks in September 1942, the Marines were relocated here from the old Dunedin Hotel. The installation was situated on the southwest corner of Curlew Creek and Alternate 19. This facility was designed to house the Marine Alligator operator trainees and their vehicles.

Lieutenant Colonel Maynard M. Nohrden became the commanding officer of the Amphibian Tractor Detachment of the U.S. Marines stationed in Dunedin. He replaced Lieutenant Colonel W.W. Davies after Davies was assigned to the San Diego Marine Base.

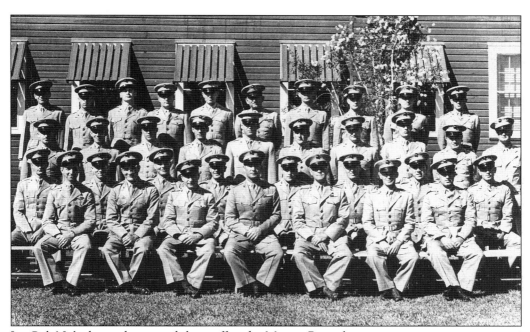

Lt. Col. Nohrden is shown with his staff at the Marine Barracks.

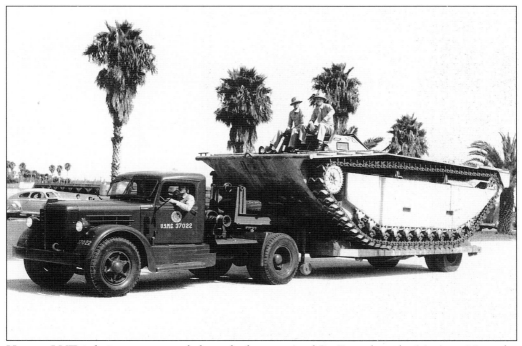

Here, a LVT is being transported through the streets of St. Petersburg by Marines. Note the bridge that connected Snell Isle with Coffee Pot Boulevard in the background. (Courtesy St. Petersburg Historical Society.)

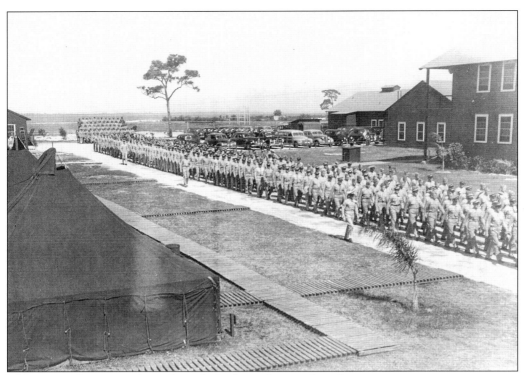

Marines are shown marching through the barracks complex after a ceremony.

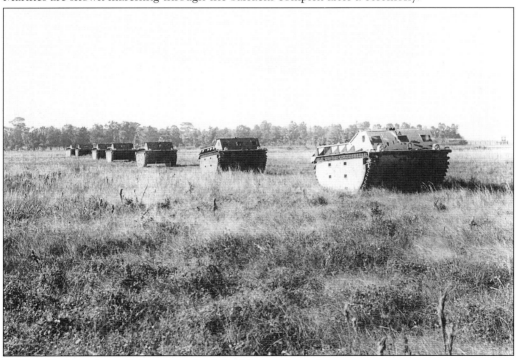

LVTs roll along the training grounds of the Marine Barracks.

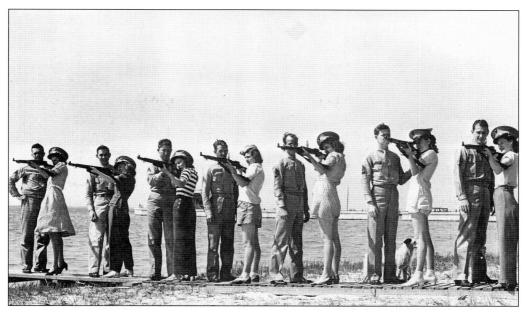

The citizens of Dunedin, especially the young ladies, made the Marines feel at home with numerous parties and dances throughout the war years. The Marines showed their appreciation to the citizens of Dunedin, especially the young ladies. Here Marine NCOs are seen giving aiming tips to these ladies on the training grounds of the Marine Barracks.

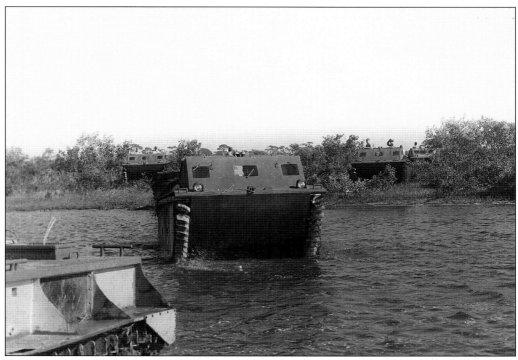

Three early LVT1s are seen rolling about the training fields of the Marine Barracks. This photograph probably dates to about 1941 or 1942.

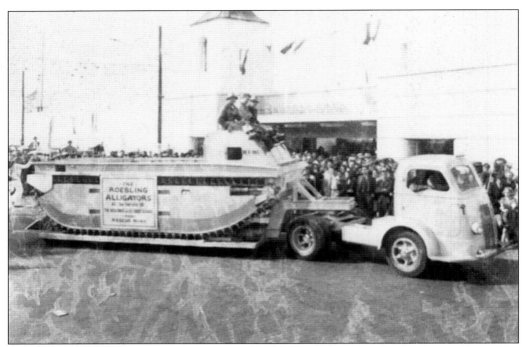

A Roebling Alligator is placed on display at the old Florida State Fair Grounds, now part of the University of Tampa. (Courtesy Special Collections, University of South Florida.)

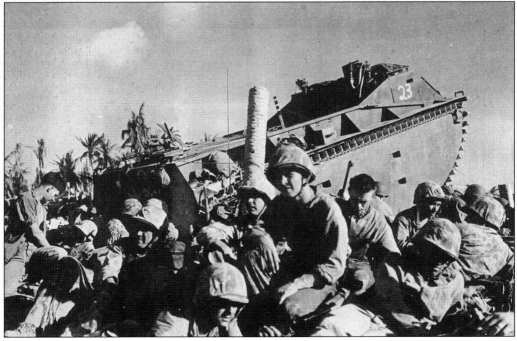

On August 4, 1944, the Marines shut down their Dunedin base and shipped out. The success of the Roebling Alligator and the LVT series can be seen in this photograph, where the marines use these vehicles in their island-hopping campaigns in the Pacific.

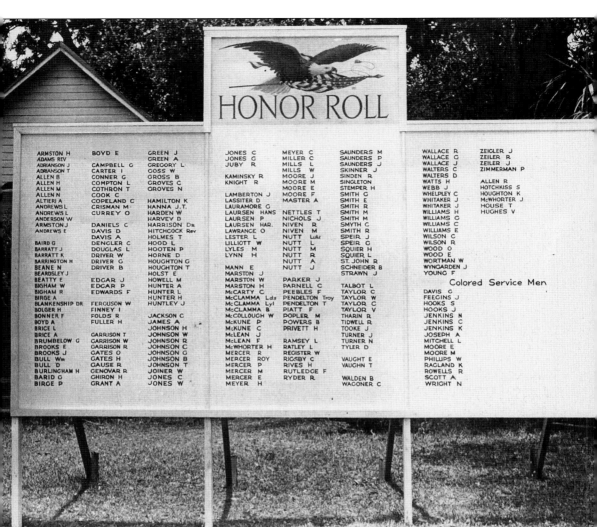

The City of Dunedin placed this honor roll of their townsmen who went off to war. Three hundred and five men from Dunedin served in the war, and nine never returned. (Courtesy of the Dunedin Historical Society.)

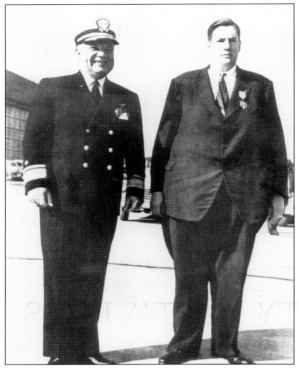

On December 18, 1946, Donald Roebling was photographed with Admiral Davidson, USN, who just awarded him a medal for merit and a citation signed by President Truman for his role with the Alligator. (Courtesy Special Collections, University of South Florida.)

Off of Alternate 19 is a small marker marking the site of the Marine Barracks in Dunedin. Nothing remains of the former training facility. (Courtesy A.M. de Quesada.)

Eight

PEOPLE AND COMMUNITY ACTIVITIES

Bartemus Brown came to Dunedin in 1870 and homesteaded 80 acres close to Jerry Lake. He also donated the land for the first Andrew's Memorial Church, which was located on the property of the present-day Dunedin Cemetery on Keene Road.

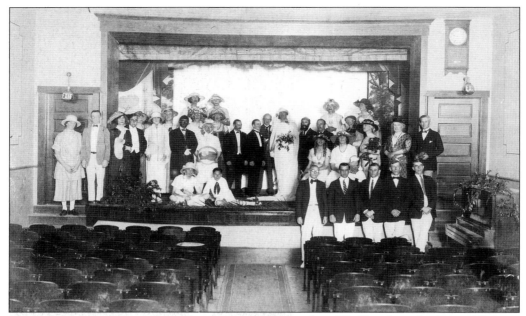

Shown here is a theatrical production of a "Womanless Wedding" at the Dixie Theater, c. 1925. Many of the individuals in this photo were prominent men who contributed to Dunedin's growth.

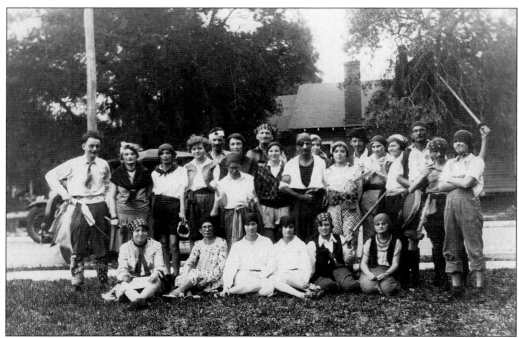

Here, a group of Presbyterian church youth poses in pirate costumes in the 1920s.

Moffet W. Moore came to Dunedin in 1875 when he was five years old. In his early adult years, Moffet was involved with the citrus and cement industries in Dunedin. Moffet later became a local real estate agent and became known as "Dunedin's First Historian" after writing the first published book about Dunedin.

Dr. Jason Edgar came to Dunedin in 1882. He was the first physician to settle in the community and opened Dunedin's first drugstore in what is now Edgewater Park.

William Y. Douglas, the brother of storekeeper John Douglas, arrived in Dunedin in 1882. William helped develop the citrus business in the area and owned 200 acres of citrus groves. He was considered to be the first photographer in the area, but unfortunately most of his early Dunedin photos were destroyed in a fire. William is also considered to be the patriarch of the present Dunedin Douglas Clan.

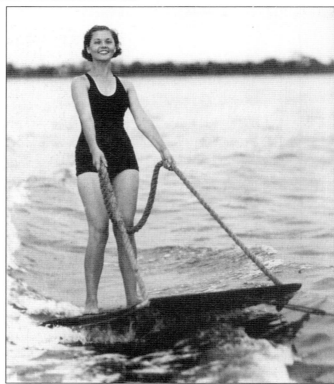

This c. 1930 photo shows Lena Mae Ray, who held the titles of both Miss Dunedin and Miss Florida. The Miss Dunedin pageant continued into the late 1980s before it was discontinued.

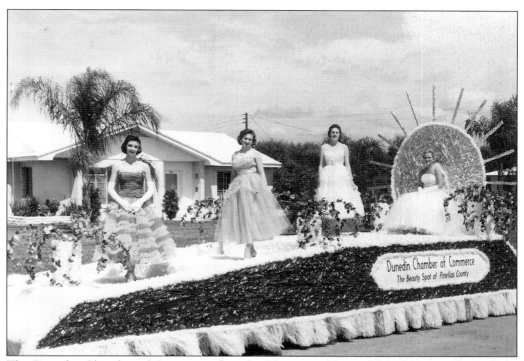

The Dunedin Chamber of Commerce float for Clearwater Fun and Sun Parade is shown here in the mid-1950s.

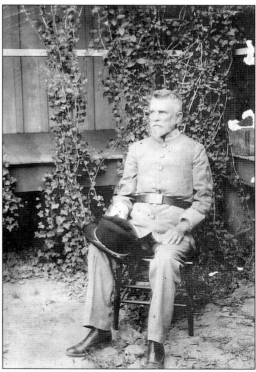

Dunedin did not exist prior to the Civil War, except for some squatters and one land owner, Richard L. Garrison. However, Dunedin did have a few Civil War veterans living in the town by the late 1890s. One of the veterans was William Conway Zimmerman, a captain in the Confederate Army. In this c. 1890 photograph, Captain Zimmerman sits posed in his reunion uniform of the United Confederate Veterans.

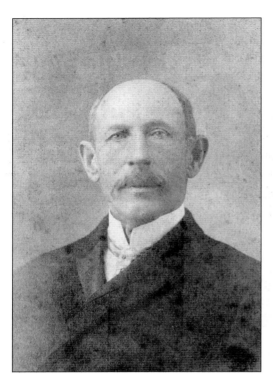

Walter Bull, along with his sisters Matilda and Lydia, purchased a great deal of land on Dunedin's waterfront in the early 1900s. It was the Bull Construction Business, which built many of the homes along the waterfront. The Dunedin Hotel on Edgewater Drive was originally managed by the Bull sisters.

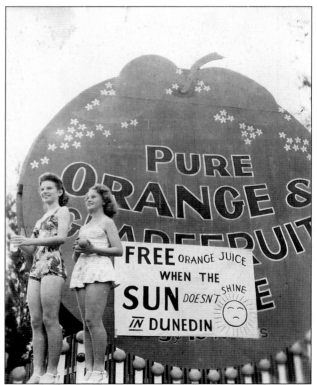

Girls ride on a float promoting concentrated orange juice in this photo from the late 1940s.

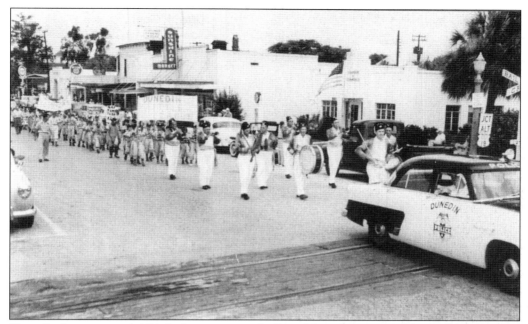

Dunedin loves a parade! Little Leaguers march down Main Street to celebrate the beginning of a baseball season in the 1950s. The building on the right (next to railroad track) housed the Dunedin Chamber of Commerce.

Mrs. Myrtle Scharrer Betz is the only child known to be born on Caladesi Island. Myrtle's father Henry homesteaded 160 acres on Caladesi, which was called "Hog Island" in the 1890s. He raised hogs and vegetables, which he sold to residents of Dunedin. Myrtle wrote a book about her life on Caladesi Island called *Yesteryear I Lived in Paradise*.

Alfred J. Grant, known as "the Grand Old Man of Dunedin," was Dunedin's first appointed town marshal and tax collector. Mr. Grant served as mayor and commissioner of Dunedin for over 30 years. He also helped organize the Bank of Dunedin and served as its president and director. The baseball stadium known as Grant Field was dedicated to him in the 1930s.

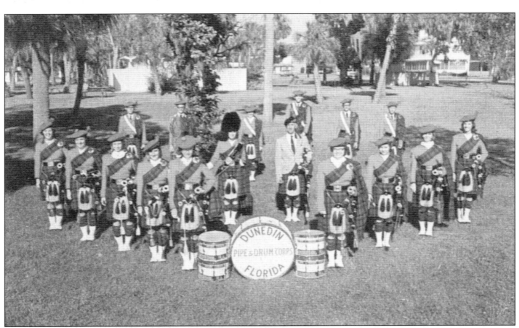

The first sound of pipes in Dunedin was heard in 1957. A Scottish lord, Roy Thomson, donated the first set of pipes at the encouragement of Bob Longstreet, mayor of Dunedin from 1972 to 1974. Highland Middle School bandmaster Bill Allen liked the idea of a marching band with bagpipes and secured the services of Matt Forsythe, originally from Scotland to teach the students, and the pipes became a tremendous success.

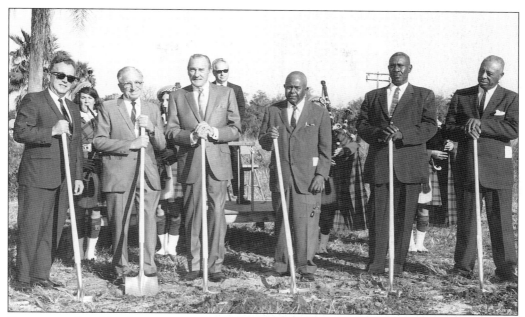

Here, groundbreaking for construction of 30 low-rent housing units is held by Dunedin Housing Authority, c. 1968. From left to right are, Si Hendry (Chamber of Commerce president), Albert Maynard and C.T. Scanlon (Housing Authority members), Charlie Hart, Rev. Mac Williams, and Frank Matthews.

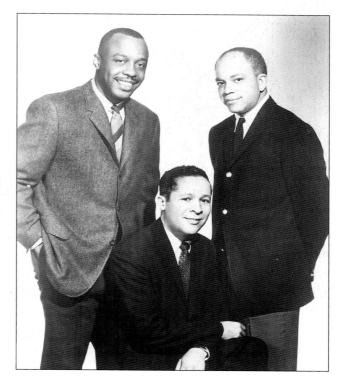

Ivory "Dwike" Mitchell (standing on left) was raised on Palmetto Street in Dunedin and is shown with his 1950s trio of musicians. As a young boy, Dwike played the piano at the Shiloh Missionary Baptist Church and went on to become a world-class jazz performer. Members of his trio during the 1950s included Charles Smith (center) and Willie Ruff. Willie still performs with Dwike on many international tours.

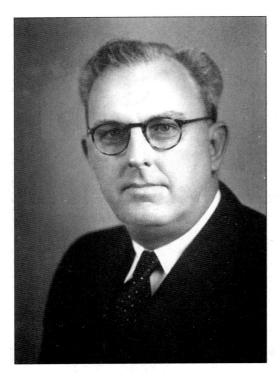

Bronson C. Skinner, L.B.'s older son, helped develop the machinery for concentrating citrus juices. By 1912, at age 21, B.C. started managing the Skinner Machinery Company and by 1935 had opened a small plant to ship concentrate to Great Britain. From 1936 to 1941 Skinner's orange concentrate plant had shipped 52,000 gallons of concentrate. In 1941 B.C. Skinner built a larger concentrate plant in Dunedin that would eventually become part of the Minute Maid Corporation. He also built an airport in Dunedin during the 1930s called Skinner's Skyport.

Dr. John Andrews Mease moved to Dunedin in 1926 and started practicing medicine in the community. While maintaining a ten-bed sanatorium at the former Blue Moon Inn, Dr. Mease opened the first section of Mease Hospital in 1937. Today that small hospital has grown into a large, modern medical institution.

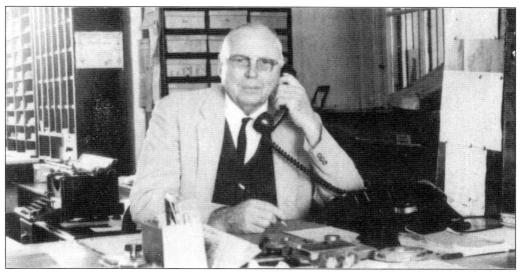

Robert U. Boyd worked for the Atlantic Coastline and the Seaboard Coastline Railroads for 33 years as station agent in Dunedin. He and his wife and eight children lived in the Zimmerman house, across from the station on Scotland Street. For 38 years his wife Pearl wrote a regular column for the *Dunedin Times* called "From My Kitchen Window."

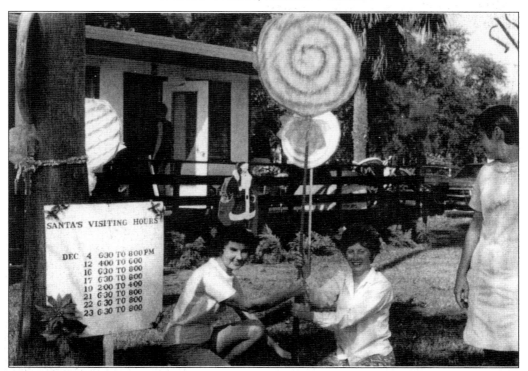

Starting in 1967, due to the initiative of Mrs. Dorothy Miller, the children of Dunedin could visit Santa at his workshop in downtown Dunedin in December. Eventually the Youth Guild took on the responsibility of getting Santa ready for December. Here several Youth Guild members get Santa's Workshop ready at No. 1 Lollipop Lane, *c.* 1970.

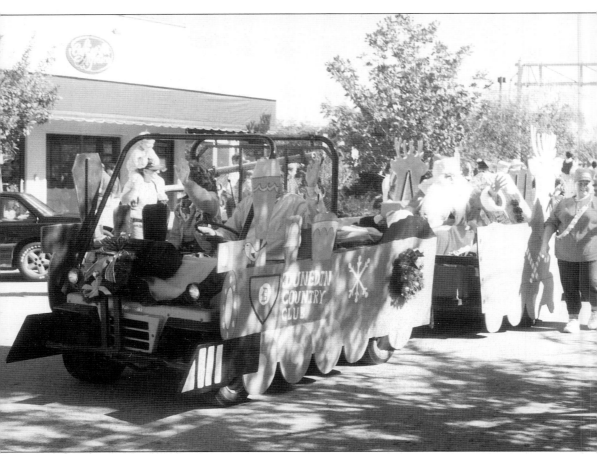

Today, many activities occur in the Dunedin community during the month of December. Besides the Old Fashioned Holiday evening festivities, Dunedin celebrates the Holiday Parade. Here, Santa passes by on his float in downtown Dunedin.

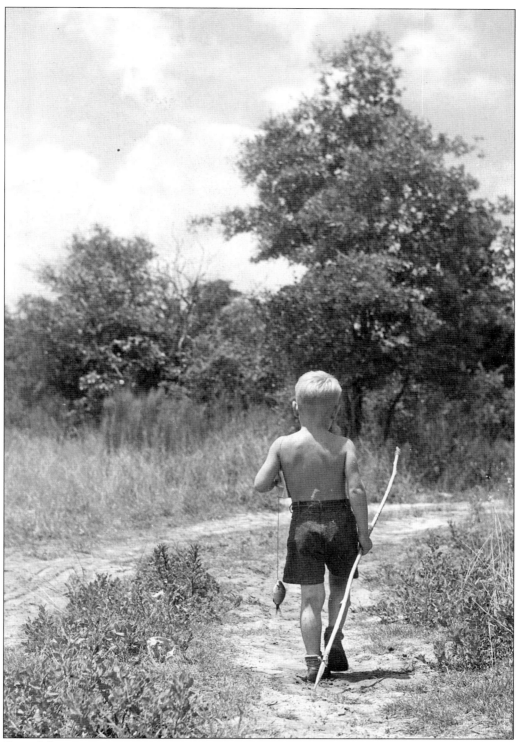

Gone fishing.